CAMBRIDGE INTRODUCTION

The Nineteenth Century

Other titles in the series

The Nineteenth Century

DONALD MARTIN REYNOLDS

The right of the
University of Cambridge
to print and sell
all manner of books
was granted by
Henry VIII in 1534.
The University has printed
and published continuously
since 1584.

CAMBRIDGE UNIVERSITY PRESS
Cambridge
London New York New Rochelle
Melbourne Sydney

To Peter C. Zlobik and in memory of Genevieve Logue Zlobik, and to their daughter, Nancy Zlobik Reynolds, my wife

Published by the Press Syndicate of the University of Cambridge
The Pitt Building, Trumpington Street, Cambridge CB2 1RP
32 East 57th Street, New York, NY 10022, USA
10 Stamford Road, Oakleigh, Melbourne 3166, Australia

First published 1985

Printed in Hong Kong by Wing King Tong Company Limited

Library of Congress catalogue card number: 82–4381

British Library cataloguing in publication data

Reynolds, Donald

The nineteenth century – (Cambridge introduction
to the history of art)
1. Art, modern – 19th century – Europe
2. Art, European
I. Title
709′.03′4 N6450

ISBN 0 521 23208 2 hard covers
ISBN 0 521 29869 5 paperback

EA

Contents

Contents

Acknowledgements

For permission to reproduce illustrations the author and publisher wish to thank the institutions mentioned in the captions. The following are also gratefully acknowledged: cover, pp 55, 57 reproduced by courtesy of the Trustees, The National Gallery, London; pp 6, 8, 30 right, 34 right, 35 left The Mansell Collection; pp 15, 19, 75, 79, 118 clichés Musées Nationaux, Paris; p 22 copyright The Frick Collection, New York; p 35 right Virginia State Travel Service; pp 36, 37 Trustees of the Wedgwood Museum, Barlaston, Staffordshire; p 39 Lauros-Giraudon; p 43 Phaidon Press Ltd; p 49 Trustees of the British Museum; pp 51, 52, 95, 98, 99 top The Tate Gallery, London; pp 59, 102 bottom left and right, 103 Board of Trustees of the Victoria and Albert Museum, crown copyright; p 62 Bildarchiv Preussischer Kulturbesitz; p 63 Verwaltung der Staatlichen Schlösser und Gärten; p 66 collection of The New York Public Library, Astor Lenox and Tilden Foundations; p 67 collection of The Art Gallery of South Australia; p 71 Leeds Art Galleries; p 73 Mansell-Giraudon; p 91 The Nelson-Atkins Museum of Art, Kansas City, Missouris (Nelson Fund); p 92 Potter Palmer Collection, courtesy of the Art Institute of Chicago, all rights reserved; p 102 top A.F. Kersting; p 104 The Syndics of Cambridge University Library; p 106 courtesy of The Detroit Institute of Arts; p 110 courtesy of The Freer Gallery of Art, Smithsonian Institution, Washington DC; p 114 reproduced by permission of the London Borough of Camden from the collections at Keats House, Hampstead; p 119 Mansell-Alinari; p 123 The Bridgeman Art Library; p 126 courtesy of the Art Institute of Chicago, all rights reserved; p 127 top collection National Museum, Vincent Van Gogh, Amsterdam

Introduction

Whether one begins a study of nineteenth-century art with the French Revolution in 1789 or with Immanuel Kant's completion of his *Critique of Pure Reason* in 1780, and ends the study around 1880 with Cézanne's early painting or in the early years of this century with the flowering of 'modern art', this historical period is chronologically defined. The reason for this lies partly in the complexity of the social, political and cultural changes that transformed Europe and the New World from the middle of the eighteenth century until the beginning of the twentieth century and which affected the world's art. Within this period, art historians have identified numerous artistic currents and movements, a fact which prevents a single designation as is possible with other historical periods, such as the 'Renaissance', the 'Baroque', the 'Romanesque' and the 'Gothic'.

This introduction to nineteenth-century art attempts to identify the major themes, concepts and stylistic characteristics of the painting, sculpture and architecture of this period. The study begins with Neoclassicism and Romanticism, terms used to describe two currents in the visual arts from approximately 1750 to 1850 that are sometimes quite distinct and at other times inextricably intertwined. Leading painters and sculptors of the period are identified and representative examples of their work are analysed.

Neoclassicism, as distinguished from other classical revivals, refers to the 'new classicism' that emerged in Rome as a reaction to the Rococo and certain aspects of the Baroque, and that spread throughout Europe and the New World. The roles of such Neoclassical pioneers as Benjamin West and Sir Joshua Reynolds are identified, and selected works of its leading painters, J. L. David and J. A. D. Ingres, illustrate the lofty sentiments and linear rendering that characterise its content and form. Often, Neoclassical art, as in the sculpture of Antonio Canova and Hiram

Powers, expressed intense sentiment, a phenomenon which is usually identified with Romantic art.

Romanticism had less precise origins and boundaries than Neoclassicism. While it shared a high sense of purpose with Neoclassicism, its expression was more subjective and less rational, a characteristic particularly evident in the art of Francisco Goya. Through his highly personal vision of the world, expressed in his themes of war and psychological conflict, for example, Goya achieved new insights into man's struggle for survival. The passion and spontaneity that are hallmarks of Romantic painting and sculpture are analysed in pictures by Théodore Géricault and Eugène Delacroix and in statuary by Antoine-Louis Barye, François Rude, and Auguste Rodin.

The Romantic sensibility is also expressed in landscape painting. The origins of the Romantic landscape are explored in the works of J. M. W. Turner, John Constable, and Caspar David Friedrich, and their influence on other major currents and movements is explained. For example, Constable's effect on the Barbizon School of painters, precursors to French Impressionism, is illustrated. The indigenous schools of landscape painting in the United States and Australia are discussed, exemplifying the variety of landscape painting in the nineteenth century.

The elements of idea and fantasy that grew to prevail in Neoclassical and Romantic art provoked a reaction among a group of young artists in France who believed that artists should paint only what they could experience with their senses. The major proponents of this new Realism were Gustave Courbet and Edouard Manet, whose ideas and techniques were formative influences on French Impressionism, the first major movement of modern art.

Interest in the accurate rendering of nature was combined with a revived interest in fourteenth and fifteenth century religious painting early in the century by a group of young German painters mockingly called 'Nazarenes'. Similarly, by the 1830s, the Pre-Raphaelites in England had carried 'truth to nature' to new heights through more precise draughtsmanship and colour in rendering objects, textures and light.

Through the heightened concern of the new Realism with its

accurate depiction of the visual perception of nature, a growing rejection of academic restrictions, and a greater respect for the preliminary sketch, French Impressionism was born in the works of a small group of avant-garde painters. In analysing some works of the major Impressionists, such as Claude Monet, Auguste Renoir, and Edgar Degas, the profound influence of this movement on the art of its own time is illustrated and its far-reaching impact on succeeding generations is studied, especially through the work of Paul Cézanne, Paul Gauguin, Georges Seurat, and Vincent van Gogh.

Effects of the Industrial Revolution on the arts and industry in England produced reactions early in the century that had far-reaching implications both there and abroad. Some of these effects are traced and their reactions illustrated in a discussion of William Morris and the Arts and Crafts Movement, the influence of John Ruskin, the century's most influential art critic, and the aestheticism of James Whistler. How aestheticism, industrialisation, and a revival of the medieval craft tradition combined with a variety of pictorial and ornamental forms to produce at the end of the century the distinctive decorative style Art Nouveau is analysed in the works of some of its leading practitioners such as Aubrey Beardsley, Louis Comfort Tiffany, and Charles Rennie Mackintosh.

1 Neoclassicism and Romanticism

INTRODUCTION

Classical themes and motifs had been fundamental to the visual arts from the Renaissance on. Neoclassicism, however, differed in its conscious selection of models that repudiated the superficiality of the Rococo and the *trompe l'oeil* illusionism of the Baroque. Artists sought to improve the world through right reason and a keen sense of morality by resurrecting and adapting models from Greek and Roman antiquity that embodied noble virtues. This rejection of Rococo frivolity and Baroque frenzy in favour of high moral purpose is seen by some historians to reflect the culmination of the ideals of the Enlightenment at the end of the eighteenth century.

The new classicism produced a fundamental change in the style and content of the visual arts throughout Europe and America. For example, delicate curves and 'C' scrolls gave way to immaculate straight lines, sensuously textured surfaces to smooth sculptural forms, and light pastels in a painterly mode to strong colours contained in clearly defined contours.

For Sir Joshua Reynolds, founder and first President of the Royal Academy, whose theories had a profound influence on the art of the period, the ancients singularly captured the simplicity of nature. He admonished artists to imitate the ancients who reduced natural forms to basic shapes and interrelationships, and thereby learn the rules of design that were timeless and of universal significance.

The new style was known at the time as the 'true style' or the 'correct style', and it was seen as a *risorgimento*, or revival, of the arts. The term 'Neoclassicism' was coined later in the nineteenth century as a pejorative label to describe the style which some critics saw as empty of meaning and devoid of contemporary significance. In 1861, William Michael Rossetti, spokesman for the

Pre-Raphaelite Brotherhood, dubbed the style 'pseudo-classical'.

The European origins of Romanticism appear disparate. It has been suggested, however, that Romantic art spins centrifugally out of Neoclassicism because, with no linear progression of its own, it deals with the complexities of the historical ideas embodied more simply in Neoclassical art. Moreover, Romanticism shares Neoclassicism's high sense of purpose. The two differ, however, in that Neoclassical art tries to express universal and timeless values, while the ultimate criterion in Romantic art is the artist's own sensibility. Neoclassical art is identified with reason, Romantic art with feeling and passion. Because of its subjective nature and its recognition of the individual's autonomy, Romantic art produced a profound shift in attitudes towards life and artistic expression in the eighteenth and nineteenth centuries that had widespread and enduring effects.

The term 'Romantic' was first used in England in the seventeenth century, and it derives from the French *romants*, or 'romances', medieval legends related in the vernacular rather than in Latin. Countless attempts to define the term have proved unsatisfactory because it covers such a diversity of meaning. For example, in the visual arts, painterly brush work has been called a Romantic characteristic, because its spontaneity is identified with feeling rather than reason. Yet there are equally Romantic works whose brush work is as imperceptible as that in any Neoclassical work. The resemblances that do exist between Romantic and Neoclassical art may demonstrate the common ground they share as well as the differences they express.

NEOCLASSICISM: SIMPLICITY AND CALM GRANDEUR

The principal theoretician of the new classicism was Johann Joachim Winckelmann. His views on Greek art, of which he believed the essence to be its 'noble simplicity and calm grandeur', were published in 1755 in *On the Imitation of Greek Works*. Among the main exponents of his ideas were Anton Raffael Mengs and Gavin Hamilton.

Mengs was a gifted court painter from Dresden; Hamilton,

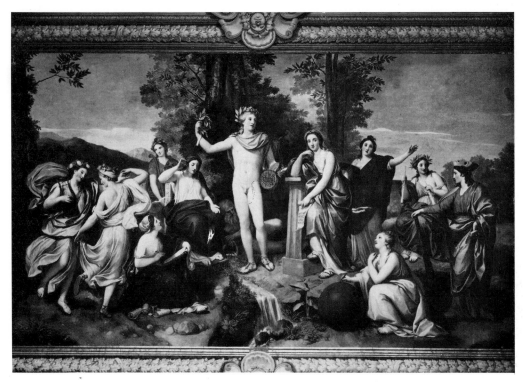

Anton Raffael Mengs, *Parnassus*, 1761, ceiling fresco, Villa Albani, Rome.

from Scotland, had been a portrait painter in London in the 1750s and settled in Rome towards the end of the decade where he met Winckelmann and Mengs. Hamilton and Mengs under the influence of Winckelmann's theories, ancient sculpture, the classicism of Poussin, and the paintings of the great Renaissance masters, developed a style of painting that was one of the foundation stones of Neoclassicism.

Mengs' first painting in the new style was the *Parnassus* in the Villa Albani in Rome, inspired by drawings he made at the excavations of Herculaneum. This town and its neighbour Pompeii had been buried by the eruption of Vesuvius in AD 79; the excavations offered an unprecedented opportunity to see well-preserved art and artifacts of antiquity. Mengs portrayed the figures parallel to the picture plane like a sculptured relief (reminiscent of Poussin) and rejected the deep illusionistic space and *trompe l'oeil* devices characteristic of Baroque wall painting. (If we compare *Parnassus* with *The Death of Socrates* (p. 9) by David, we can see how in a fully developed Neoclassical work, a relief style is still one of the guiding principles.)

Hamilton's paintings at this time also stressed archaeological correctness, now made possible through the discoveries at

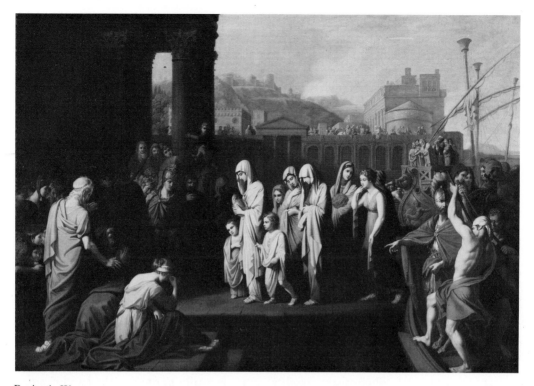

Benjamin West,
*Agrippina Landing at
Brindisium with the Ashes
of Germanicus*, 1767/8,
oil on canvas,
164 × 239 cm, Yale
University Art Gallery,
gift of Louis M.
Rabinowitz.

Herculaneum and Pompeii. Hamilton was not only a painter but also an art dealer with international connections and therefore in a position to promote the new style beyond the boundaries of Rome. He had his pictures engraved by Domenico Cunego. Engraving was not a new technique (it had been used similarly since the Renaissance) but it gave a wide circulation to Hamilton's compositions and to the works of the Renaissance masters that Hamilton also published.

In 1760, Benjamin West from Pennsylvania (who was to become a founding member of the Royal Academy in England, 1768, and its second President) arrived in Rome to study the great works of art there. He too responded to the ideas of the Winckelmann circle. After three years in Italy, West settled in London in 1763 and carried with him the principles of the new style, which he demonstrated in *Agrippina Landing at Brundisium with the Ashes of Germanicus*.

The central figure group, emphasised by lighting reminiscent of the Baroque painter, Caravaggio, is based upon drawings West made of the reliefs of the *Ara Pacis* in Rome. It conforms to the compositional principles Mengs had pioneered in *Parnassus*, figures arranged parallel to the picture plane and modelled like

7

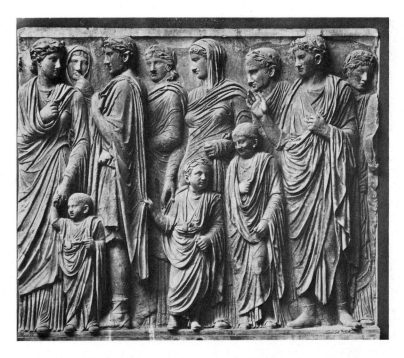

an ancient relief. Although the space in West's picture retains an
illusionistic quality that is still Baroque, the architectural
background reduces the depth in a box-like fashion that antici-
pates David's later work.

JACQUES-LOUIS DAVID Jacques-Louis David (1748–1825)
was trained at the Ecole des Beaux-Arts (School of Fine Arts) in
Paris. He won the Prix de Rome in 1774, an award that enabled
him to study at the French Academy in Rome, where he remained
from 1775 to 1781. During that time, David was profoundly
influenced by the ancient world itself as well as by modern
interpretations of it.

David became the major painter in the Neoclassical movement;
his *Death of Socrates*, which he exhibited in the Paris Salon of
1787, is a good example of his contribution to the formation of a
new style of painting in Europe.

David portrays Socrates, the father of Western philosophy, at
the moment of taking the fatal hemlock, after he had been
condemned to death for his teachings. The injustice of Socrates'
sentence and the circumstances of his fate were paralleled by
political martyrdoms in David's own day (caused by the French
Revolution and events that came in its wake). He manages to get
over the message that 'the virtues of Antiquity are valid today',

8

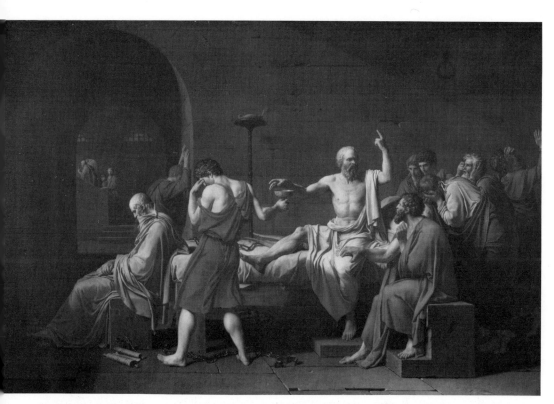

Jacques-Louis David,
The Death of Socrates,
1787, oil on canvas,
130 × 196 cm, The
Metropolitan Museum
of Art, New York, Wolfe
Fund, 1931.

and to make this painting of an event familiar to all educated people in eighteenth-century France, immediate, relevant and credible, by technical devices. The modelling of the figures is natural, the illusion of space is convincing, and the use of light and shade is dramatic. By the use of these devices he removes the veil of time between Socrates' work and his own and enables his contemporaries to identify with the event in a fresh and personal way.

Anatomy is depicted with precision: heads, necks, torsos relate to each other with physical accuracy. Socrates' flesh, painted with lively naturalism, is chafed where the manacles (lying beneath his right ankle) had bound it; his disciple's right hand closes over the master's knee in a gesture that conveys the intense anxiety that pervades the scene. Although Socrates' portrait is based on a well-known ancient sculptured bust, David's naturalistic rendering gives it a quite different feel from that of the original.

David's figures are arranged parallel to the picture plane in the tradition of the classical painter Nicolas Poussin; however, they depart in spirit from the ballet-like character of the earlier master's figures. Not only are David's figures more naturalistic in their

gestures, but the way they intermingle within the naturalistically rendered architectural interior creates a convincing sense of space. Modelled like ancient sculpture and illuminated by a dramatic chiaroscuro that is indebted to Caravaggio, his figures are more like the sculptures of the ancient Greeks and Romans.

Although David researched the historical background of Socrates' death to give it a sense of factual authenticity, he changed certain aspects in order better to point the moral message he asked the painting to give. For example, he suggests a parallel between Socrates' sacrifice and that of Christ. Socrates, surrounded by his disciples (twelve in all, six on either side of him), is about to take the cup of poison, the central focus in the painting. The scene resembles that of the Last Supper, as depicted in many paintings with which David's contemporaries would be familiar: the hand extended in blessing, the cup, the twelve disciples.

The use of Christian iconography in order to invest a non-religious subject with nobility and moral significance was an accepted device at this time (as we shall see in West's *The Death of General Wolfe*). But David brought to his personal use of this device an innovative power that was rare and that enabled him to endow the human virtues of courage, commitment, fidelity and sacrifice with contemporary meaning.

By portraying Plato as the same age as Socrates, instead of almost thirty years younger, as he was, David invests the pupil with authority derived from the teacher. By clothing Plato in the same coloured mantle as Socrates, he symbolises the perpetuation of Socrates' ideas through the writings of Plato. Placed at the foot of Socrates' bed, in the posture of an ancient statue, and framed by the giant arch behind (another anachronism because it is a Roman arch), Plato sits with legs crossed at the ankles. This was a gesture popular in eighteenth- and nineteenth-century funerary art, suggesting the eternal sleep of Endymion (so, a symbol of death).

In *The Oath of the Horatii*, acclaimed in Rome and in Paris at the Salon of 1785, and *The Lictors Returning to Brutus the Bodies of His Sons*, David chose to treat two events from ancient Rome that glorified the virtues of patriotism, courage and sacrifice. Once again, the subjects were also meant as political commentaries on the France of his own time.

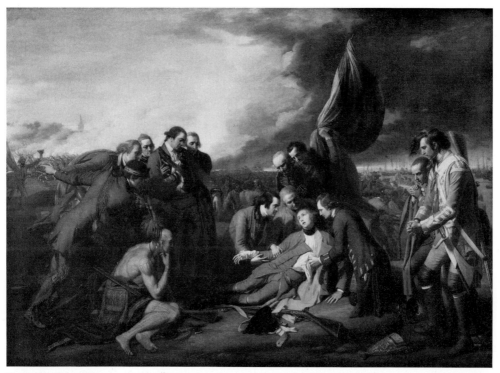

Benjamin West, *The Death of General Wolfe*, 1770, oil on canvas, 151 × 213 cm, National Gallery of Canada, Ottawa, gift of the Duke of Westminster, 1918.

A NEW ERA IN HISTORY PAINTING At the same time as the depiction of antiquity was being charged with a moral message to contemporary society, a fundamental change was also taking place in history painting. Benjamin West was involved in both: in the first through the part he played in the development of the style culminating in David's *Death of Socrates*; in the second through his originality in choice of subject and the iconography he employed in its treatment. From the standpoint of the twentieth century it is difficult to appreciate the importance ascribed by people in the nineteenth century to history painting, but it was referred to at the time as 'the noblest form of art'.

West chose an event that had taken place only eleven years before, and he portrayed its participants in contemporary dress and setting. In this he violated the accepted academic standards for a history painting, which required subjects distant in time. Acceptable subject matter consisted of ancient Greek and Roman history, mythology, and the Bible. General James Wolfe had commanded the British troops against Quebec in the French and Indian War. On the Plains of Abraham, 13 September 1759, he defeated General Louis Joseph de Montcalm (who was also mortally wounded in the same battle) and won New France for

England. Sir Joshua Reynolds, President of the Royal Academy, who had lectured to the Royal Academicians on appropriate dress and subject matter in history painting, was at first opposed to West's idea; however, when the President saw the finished work, he was convinced that West had succeeded in portraying a contemporary event in the grand style (that is, the style appropriate to history painting). In fact, Reynolds prophesied that the painting would occasion a revolution in art.

It has been suggested that Sir Joshua's remarkable conversion was due to West's success in investing the event with nobility, dignity and pathos through the use of traditional Christian iconography and his conformity to the stylistic standards and techniques of the great masters. Moreover, the overall composition and certain details derive from works by such old masters as Dürer, Rembrandt, van Dyck and Giotto, and from models of seventeenth-century academician Charles Lebrun. By placing the Indian warrior prominently in the composition, distance of place (the New World) substitutes for the distance of time (antiquity) required by academic convention. West remarked that the Greeks and Romans never knew of such a place, therefore Roman or Greek dress and accessories would be inappropriate.

When the painting was exhibited, it was a great success with the public, who flocked to Pall Mall to view it, and some even 'swooned' from the emotional impact of the painting. The impact was not limited to England alone; West had engravings made of the picture (no doubt, recalling Hamilton's success) which were circulated nationally and internationally. The print was to some extent the visual counterpart of the novel; it opened up a much broader audience for art than had existed before.

ROMANTICISM: PASSION AND SENSIBILITY

As West's *Death of General Wolfe* extended the boundaries of history painting, and thereby opened up new possibilities for that genre, his *Death on the Pale Horse* showed him again as an innovative stylist. This painting was inspired by the *Book of the Apocalypse* and Edmund Burke's *Philosophical Enquiry into the*

Origins of our ideas of the Sublime and the Beautiful (1757). It expresses characteristics of the 'terrible' sublime, that which causes pain and excites terror, as opposed to the beautiful, which calms and pleases. He portrays a family struggling against a stampeding personification of Death, expressing Burke's theme of man's instinct for self-preservation and the conflicts that entails.

Burke's ideas also inspired numerous other artists such as William Blake, Henry Fuseli and James Barry, but West's painting had an immediate effect, because of circumstances, that assures its place in the development of Romantic painting in Europe. West took his painting to France in 1802, following the Treaty of Amiens between England and France in which France agreed to evacuate Naples and England agreed to give up certain conquests made in the French Revolutionary Wars. At that time, a group of English Academicians went to see Napoleon's art treasures. Compared to David's Neoclassical style in vogue then (a style West himself had pioneered), *Death on the Pale Horse*, drawing largely on the Baroque compositions of Peter Paul Rubens, was a dramatic new departure that, for the moment at least, seemed stylistically a backward step. West's painting was not forgotten. It anticipated the work of the great French Romantic painters Théodore Géricault and Eugène Delacroix.

The theme of humanity's struggle for survival against nature on a less grandiose level was also pioneered in England by another artist, John Singleton Copley, who, like Benjamin West, had come from the colonies. Encouraged by Benjamin West and Sir Joshua Reynolds, he left America shortly before the outbreak of the American Revolution, became a Royal Academician, and remained in England the rest of his life.

In 1778, Copley followed West in elevating a contemporary event to the level of history painting with his *Watson and the Shark*; however, he went a step further than West in choosing an event that was of no historical or political significance (though Brook Watson, the victim, did become Lord Mayor of London). Watson had been swimming in Havanna harbour when a shark bit off part of his leg. Copley painted the event in the grand manner of a history painting with the central group organised in a pyramidal composition, the figure about to kill the shark rendered in a

familiar pose of an archangel or St George slaying the dragon, and Watson's nudity reminiscent of antiquity. Copley introduced the theme of every man's battle for survival against the elements of nature, that forty years later was to be taken up by Théodore Géricault, France's first major Romantic painter of the nineteenth century, in his *Raft of the Medusa*.

THEODORE GERICAULT The *Medusa*, a French government ship, full of colonists, foundered in a storm off the coast of Africa as a result, it was said, of the captain's incompetence. There were few lifeboats and many lives were lost. The public saw the tragedy as an indictment of the government's disregard for the wellbeing and safety of its subjects. Deeply moved by the disaster, Géricault (1791–1824) selected an especially poignant and wrenching moment in which a group of survivors, frantically waving to a passing ship for assistance, go unseen; some continue the effort, others fall back among the dead and dying in despair.

Almost 150 survivors, crowded onto the raft, were adrift for twelve days, during which all but fifteen died. Through interviews with some of those who survived and newspaper accounts of the ordeal, Géricault pieced together a macabre mosaic of cannibalism, mutiny, and prolonged physical and psychological torment. From the morgue he secured bodies in order to study the different stages of decomposition, and in a hospital he sketched the faces of deranged people. He built a model raft in his studio. He studied the movement of the waves at Le Havre. His ambition was to combine the sense of immediacy of the actual event with the monumentality of history painting. A Baroque pyramidal composition of dead and agonising bodies terminates in the figure of a black survivor (recalling the black man in Copley's painting) frantically signalling for help; dramatic chiaroscuro underscores the extremes of despair and hope. The influence of Michelangelo's *Fall of the Damned*, which Géricault had seen on his visit to Italy in 1816, is evident in the anatomy and gestures of the tortured figures and their organisation. By including Delacroix (at the apex of one of the pyramids) and another painter friend, Louis-Alexis Jamar (in the foreground), as models, Géricault strengthened the element of truth to life.

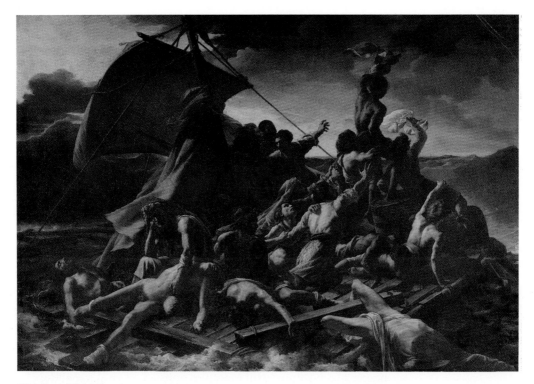

Théodore Géricault,
Raft of the Medusa, 1819,
oil on canvas,
491 × 716 cm, Louvre,
Paris.

Although he won a medal for the painting in the Salon (the annual public exhibition in Paris) of 1819, Géricault was never satisfied that he had done justice to the subject. After the Salon, he sent the painting on tour through England and Scotland (1820–22) where, consequently, it became widely known. In England, he met a number of Royal Academicians and was especially impressed with John Constable's landscapes. While there, he made many drawings of contemporary life. These were masterpieces of reporting, from which he produced prints in the new medium of lithography. (Géricault was one of the first artists in France to make lithographs, a process invented in 1798 by Alois Senefelder.)

Géricault's lifelong fascination with horses found expression in painting English race meetings. A keen horseman, he was to die young as a result of injuries and subsequent complications from a succession of falls while riding. He was especially fond of Baroque equestrian paintings (his fellow students had nicknamed him 'Rubens' cook', suggesting his subservience to the master) and of George Stubbs' work, both for his violent animal studies that introduced a new theme to Romantic art, and his unique and meticulous anatomical studies (*Anatomy of the Horse*).

Géricault came from a well-to-do family in Rouen. He studied with Carle Vernet and then with David's pupil Baron Pierre-Narcisse Guérin. Baron Antoine Jean Gros, another pupil and close friend of David, also had a strong influence on Géricault in his emphasis on colour and composition. Géricault's style, however, developed along more painterly lines; in other words, whereas the Neoclassical painters created forms defined with lines, Géricault's forms were made with masses of colour. He rejected the academic practice of detailed preparatory drawings.

As a portrait painter, Géricault exhibited uncommon psychological insight in a series he painted for his friend Dr Etienne Georget, a pioneer in France in treating emotional illness. As part of his clinical research of the insane, Georget wanted a permanent record of his patients' likenesses in order to demonstrate the relationship between the individual's thoughts and his facial appearance. The paintings he commissioned from Géricault are among the most powerful examples of psychological portraiture in the history of Western art. They are also superb examples of the Romantic sensibility that Géricault's paintings did so much to formulate.

In simplifying the portrait by reducing the number of elements to the bare essentials, Géricault intensifies the focus on the subtleties of the sitter's expression (as seen in *Madwoman* and *Madman*). Because the flesh around the eyes and mouth is the most plastically susceptible to the changes in emotional states, these features are the most expressive parts of the human face. Géricault's grasp of this fact enables him to unify gesture, position of the head, and the use of colour and light in consummately revealing the maximum range and intensity of expression.

The faces are portrayed somewhere between frontal and three-quarter view and show both eyes and the entire mouth. The heads are placed high on the canvas against a dark monochromatic background. The clothing is dark, and therefore recedes as if in shadow, and is summarily painted. A soft light behind the head and a white collar, or a halo-like head covering, further delineates the face. Chiaroscuro effects indicate a source of light that shines on the face from slightly to one side. The side of the face in shadow, however, is not totally eclipsed, so that the entire visage

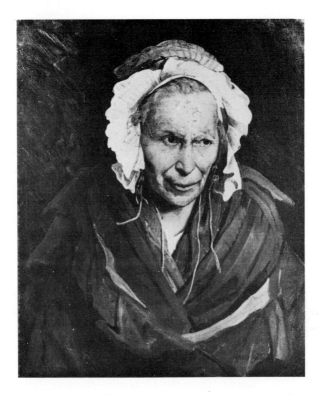

Théodore Géricault, *Madwoman*, *c.* 1822, oil on canvas, 72 × 58 cm, Musée des Beaux-Arts, Lyons.

may be read. The painterly treatment of the faces portrays the reality of internal states through the surface reality of appearances; the general impression is one of respect for the individual's humanity. The fine focus of a gaze (*Madwoman*) or a distracted stare (*Madman*) is captured by the cast of the eyes and the way the artist shows the relationship between the iris and the pupil. A gesture is recorded in the tilt of the head; a fold in the cheek responds to the set of the mouth.

EUGENE DELACROIX With Géricault's tragic death in 1824 at the age of 32, the major painter working in the Romantic mode was Eugène Delacroix (1798–1863), who had admired Géricault and, like him, studied with Gúerin and idolised Gros. Two years before, the critic Adolphe Thiers had hailed Delacroix's first work exhibited at the Salon, *The Bark of Dante and Virgil*, as announcing a great talent of the new generation in his poetic imagination, draughtsmanship, and composition reminiscent of Michelangelo and Rubens. When he exhibited *Scenes from the Massacre at Chios* in the Salon of 1824, however, the writer and critic Stendhal, while commending Delacroix's appeal to the public (some even cried) and his feel for colour (calling him an heir

17

of Tintoretto), pronounced the painting not a 'massacre' but a 'plague scene'. It did not include an executioner and a victim, which any respectable 'massacre' must have. Nor did the figures look like Greeks; furthermore, their clothing was incorrect.

Many of Delacroix's paintings were inspired by Dante and Shakespeare as well as by such Romantic writers as Lord Byron. In this, too, he broke with convention, which traditionally drew on the literary sources of antiquity. But he also used as sources both history and contemporary events. He shared with Byron a concern for contemporary events that involved the anguish of the human condition, both physical and psychological. It was one such event, the Greek War for Independence, which had led Delacroix to portray the massacre of Chian Christians by the Turks in 1822. The Island of Chios was traditionally held to be the birthplace of Homer, so it had special symbolic importance during the struggle.

Another painting exhibited at the 1824 Salon, now even more famous than the Delacroix painting, was *The Hay Wain* by the English painter John Constable. When Delacroix saw Constable's extraordinary naturalness he repainted the background of his *Chios*. The following year, he travelled to England to study English painting more closely. There, he met the Royal Academicians and made many studies of horses, as had Géricault before him. English painting may have influenced his most liberated work, *The Death of Sardanapalus*, which was severely criticised in the Salon of 1829 for its brilliant colour, excessively free brushwork and lack of finish.

The story of the dissolute emperor Sardanapalus was told by Lord Byron, and it was his verses in *Sardanapalus* that inspired Delacroix's picture. Sardanapalus, the last in a line of decadent Assyrian rulers, is under siege without any chance of survival. Delacroix chooses the moment in which Sardanapalus orders all of his possessions to be brought to him – harem girls, horses and guards. They are to be executed, and finally consumed by fire with him.

Delacroix organised the bizarre scene around an exotic cornucopia-like diagonal from which pours all manner of glittering riches. Originating with the figure of the emperor at the upper left, and defined by the bodies in varying stages of nudity

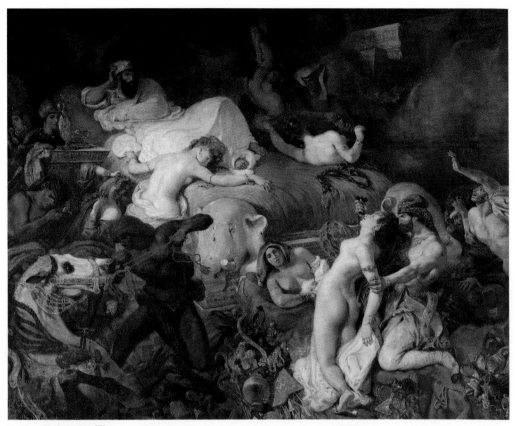

Eugène Delacroix, *The Death of Sardanapolis*, 1827, oil on canvas, 395 × 495 cm, Louvre, Paris.

and consciousness displayed against the flaming red drapery of the imperial couch, it swells to encompass the figure group at the lower right. An arc, created by the animated gesture of the male figure reaching towards the emperor and continued in the crescent figure of the harem girl being stabbed, directs attention towards Sardanapalus and the Circassian slave lying at his feet, the principal focus of the painting. Painting this woman from a race noted for its beauty of proportions and colouring, Delacroix captures the subtle range of Circassian flesh tones and characteristic chestnut hues of hair and eyes. Through carefully highlighted passages in the shadows to the left and right of the central diagonal, Delacroix further enriches the exoticism of the story with additional writhing figures: at lower left, a slave struggles with one of Sardanapalus' prize animals, to be sacrificed with his other possessions. At the upper right the human sacrifice continues.

Delacroix's supremacy as a figure painter is eloquently exemplified in *Greece on the Ruins of Missolonghi*, which he

19

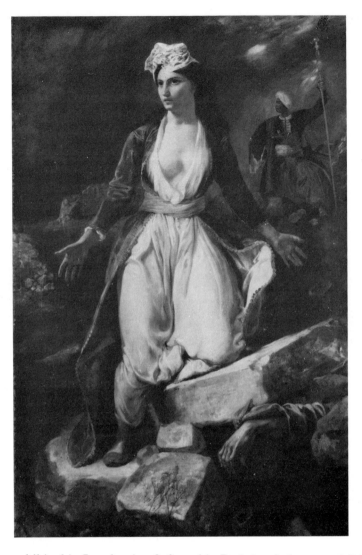

Eugène Delacroix,
*Greece on the Ruins of
Missolonghi*, 1826, oil on
canvas, 213 × 142 cm,
Musée des Beaux-Arts,
Bordeau.

exhibited in London in 1828, and in Paris in 1826 at an exhibition
to benefit the Greeks' struggle for independence.

Missolonghi was a major stronghold of the Greek insurgents
against the Turks during the war. The Turks besieged it
numerous times between 1822 and 1825 when Delacroix was
moved to paint the picture. Moreover, Lord Byron, whose
writings and energies had been dedicated to the Greek cause, had
died there of a fever in the siege of 1824, and was honoured as a
hero of the Greek cause.

Delacroix represents Greece as a lifesize figure that occupies
almost the entire central vertical axis of the painting (which is over
two metres high). She turns her back on the triumphant Moor in

the right background and opens her arms as a modern-day madonna seeking her dead youth amidst the ruins of a siege. Life-giving breasts are bared, and the soft warm contours of her figure are defined by gently falling folds of blue and white drapery. Delacroix shared with John Constable the ability to convey warmth through cool hues. The light enters the picture from the spectator's left. Greece looks toward it and her figure is defined against the mourning landscape shrouded in bleak darkness. The funereal sky in chill, deeply toned blue keyed to Greece's flowing outer garment, recedes. She stands against the background as an enormous, comforting beacon. Originally, Delacroix conceived the figure of Greece as an embodiment of despondence; however, in the finished work, she is an allegory (the word he used) of hope, full of anguish, but an incarnation of the will to live. Delacroix charges the crushed and lifeless limb of her warrior with the meaning of a sacrificial symbol. While Géricault had made many studies of anatomical fragments for his *Raft of the Medusa* for the purpose of authenticity, Delacroix now uses the fragment for a transcendent meaning.

Although Delacroix was revered by younger artists, and some of the critics recognised his importance as a painter, official acceptance was slow because of the dominant position of the classicists. However, by 1830, there were shifts in patronage and Delacroix began to achieve some official favour and some government commissions. At that time, he travelled to the Middle East to see first-hand the places and cultures that had fascinated him for so long. Théophile Gautier, in his review of the Salon of 1841, called Delacroix 'the true child of this century' and prophesied that the 'future of painting is being realised in his canvasses'. A gifted writer as well, Delacroix in his *Journal* (1822–24; 1847–63) goes beyond matters of art and offers useful insights into the society of his time.

JEAN AUGUSTE DOMINIQUE INGRES Jean Auguste Dominique Ingres (1780–1867) was a major force in the Academy in support of the classical tradition. He was also Delacroix's chief rival. He was born in Montauban, near Toulouse, and he studied first at Toulouse Academy. Then, in 1797 he went to Paris to

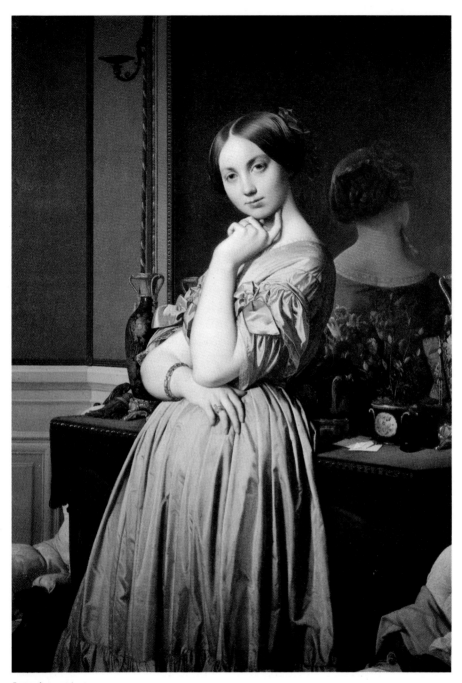

Jean-Auguste
Dominique Ingres,
Comtesse d'Haussonville,
1845, oil on canvas,
135 × 92 cm, © Frick
Collection, New York.

study with David. The rivalry between Ingres and Delacroix went beyond personal competition. It epitomised the longtime polarity that existed in the Academy between the Poussinistes on the one side, claiming to preserve the purity of line, drawing, and the

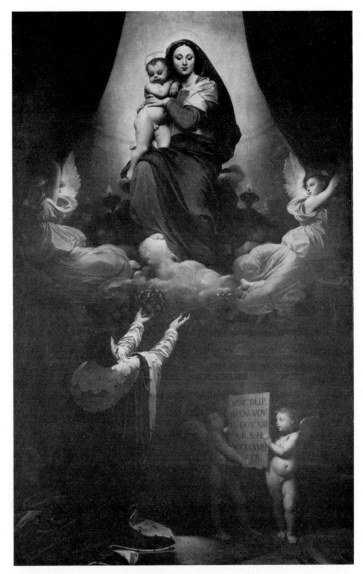

Jean-Auguste
Dominique Ingres, *The
Vow of Louis XIII*, 1824,
oil on canvas,
421 × 262 cm,
Montauban Cathedral.

classical tradition embodied in the art of Nicolas Poussin, and the
Rubénistes on the other, whose allegiance to colour and the
painterly mode was exemplified in Peter Paul Rubens' work.

In 1824, when Delacroix exhibited *Scenes from the Massacre of
Chios*, Ingres exhibited *The Vow of Louis XIII*, which had been
commissioned in 1820 for Montauban Cathedral (and was painted
in Italy, where he had been since 1806). The painting shows Louis
XIII placing France under the protection of the Virgin of the
Assumption in gratitude for her intercession when he defeated the
Duke of Saxony in 1636.

23

These two works are good examples of the opposing views within the Academy. While Delacroix's picture was criticised, Ingres' painting was generally praised, specifically for its faithfulness to the high standards of classical art and its superior drawing, an indication of the sheer power of Ingres' talent. The painting placed him in the forefront of the opposition to the Romantic Movement.

There were those, however, who criticised Ingres' borrowing from Raphael's Sistine Madonna, and the painting's too material beauty. The Madonna was voluptuous and the Child was anything but divine. They thought Ingres had divested the theme of its religious character. Moreover, the clouds upon which the Virgin stood resembled marble more than clouds, and the rendering of the king was considered to be too weak for a regal figure. Nonetheless, Ingres' distinction between the heavenly and the earthly realms is a *tour de force* in line and colour. The heavenly realm of the Madonna and Child, bathed in warmth and the suggestion of infinite depth, together with the soft, round contours, dramatically contrasts with the shallow space, cool tones, sharp reflections and angular drapery folds that characterise the earthly realm of Louis XIII.

Ingres painted many subjects from literature and antiquity and created numerous bathing and harem scenes reflecting his attraction to and mastery of the female nude figure. He developed a rich 'vocabulary' of elegant figures which he frequently repeated, sometimes with only minor variations.

Among Ingres' major achievements was the perfection of the portrait style developed by David. This too had widespread influence on artists into the twentieth century. His portraits are a complex of subtle relationships between two and three dimensional forms. Flesh, face, arms and bosom tend to be read more two dimensionally, like abstracted essences, while inanimate objects, which are many and highly detailed, tend to be more three dimensional as in his portrait of the *Comtesse d'Haussonville*. In his fastidious attention to the realistic representation of refined textures in drapery, bureau, mirror, ribbon and the numerous other objects in the picture, Ingres eradicates all traces of brushwork. He combines accuracy of drawing and elegance of line

to create the illusion that nothing stands between the object and the spectator.

Analysis of the formal components of this illusionism of Ingres is useful in understanding his interpretation of the real and the ideal, a concern that pervades all nineteenth-century art. The face, neck and arms of the Comtesse are worked to an ivory finish, without natural lines, making the surfaces, at first, appear quite flat. Closer examination, however, especially of the face, reveals how Ingres manipulates a surprisingly limited yet subtle range of tones, reminiscent of the madonnas of Raphael, for whom he had a lifelong admiration. The silhouette is clearly and precisely drawn, framed by her hair and the curved left index finger and hand placed beneath her chin. Ingres borrows this motif from the antique, which influenced Picasso's portrait of one of his mistresses in the twentieth century. Warm shadow, along her left cheek, continues the line of her left index finger and allows the plane to recede, modelling the soft contour of her youthful face. Her muted reflection in the large rectangular mirror, cut by the frame at the top and right, emphasises the Comtesse's nearness to the spectator and her participation in the spectator's space. The device of the corner portrait, in which two wall planes meet to create a sense of environment, has its origins in Early Netherlandish painting in the works of Petrus Christus and Dieric Bouts. This is not a surprising source for Ingres; after all, his debt to the central panel of the Ghent Alterpiece of 'Jan de Bruges' (Jan van Eyck) was noted by critics, for example, in his portrait of Napoleon exhibited in the Salon of 1806.

In his portraits, Ingres combined elements of representation and abstraction within a linear style to create a unique union of the real and the ideal. Juxtaposing his *Comtesse* with Géricault's *Madwoman* (discussed above) demonstrates the strengths and the power of both the Neoclassical and the Romantic sensibilities in portraiture, as well as their profound differences. Essential to Géricault is how the state of mind of his subject is expressed in her face, which, therefore, occupies most of the canvas. Géricault's spontaneous brushstroke and broken colour add to the emotional intensity of the subject's expression. Ingres, on the other hand, focusses attention on the shapes and textures of everything in his

picture; the Comtesse shares the artist's attention with every other object in his composition. Ingres' immaculate line, apparent absence of brushstroke, and subtle nuances of colour and light create a remarkable clarity and immediacy that is characteristic of his portraits.

FRANCISCO GOYA Another important artist whose art embodied the Romantic sensibility of his age is Francisco Goya (1746–1828). Born in Fuendetodos, he studied and worked in Saragossa and Madrid, and for a short time in Italy. At that time Spain stood somewhat outside the mainstream of European life, and so he worked to some extent in isolation and his most powerful works only became known outside Spain after his death, even though he anticipated by some years some of the innovations in subject matter and technique of Géricault, Delacroix and Manet.

In his day, Goya was known in Spain as a portraitist, history painter and church painter. After an apparently turbulent youth, he adapted himself to the courtly establishment and rose to hold the position of Principal Painter to Charles IV, King of Spain. In 1792, he suffered an almost fatal illness (probably brought on by a venereal disease) which left him deaf. Goya continued in favour at the court and remained there until 1824, when, disturbed by political unrest, he left Spain and settled in Bordeaux.

Goya was primarily influenced by the monumental figures in the ceiling decorations of the Royal Palace in Madrid painted between 1762 and 1767 by Giovanni Battista Tiepolo, the last of the great Venetian painters; the enduring realism of Velazquez's portraits; and the psychological insight into his subjects that Rembrandt revealed in his portraits.

In fact, Goya's frank depiction of the physical deficiencies and psychological weaknesses of the subjects in his royal portraits has puzzled art historians for many years. It is his penetrating insight and his highly personal vision of the world expressed in both his paintings and his prints that identify Goya with the Romantic sensibility of the period.

As deafness grew, Goya's art became increasingly expressive of a private world of fantasy, interior conflict and human suffering. Its wide range and depth of awareness is revealed in his prints. In

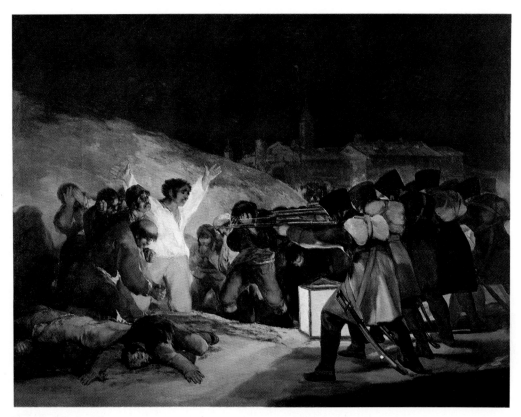

Francisco Goya, *The Third of May 1808*, 1814–15, oil on canvas, 267 × 356 cm, Prado, Madrid.

the *Caprichos*, Goya produced a series of prints that sharply attacked political intrigue, clerical decadence, and the vanity and hypocrisy of Spanish society. He was one of the first major artists to use the print as a didactic medium with such moralising force. A second series called *The Disasters of War* record in unprecedented detail a horrible variety of atrocities, from torture of all descriptions to decapitated corpses impaled upon denuded trees, atrocities precipitated by Napoleon's invasion of Spain in 1808 and the subsequent rule of Joseph Bonaparte.

The *Disasters of War* prints were executed in aquatint, a medium which Goya made peculiarly his own. The medium may have been used a century earlier by Jan van de Velde, and had been revived in the 1760s by Jean-Baptiste Le Prince. It is a form of etching by which subtleties of tone and variations of texture can be achieved to create dramatic blacks, impossible within the limitations of conventional etching. Goya's aquatints have never been equalled in power of expression, versatility of line, or delicacy of tone.

It is not surprising, then, that Goya also took the opportunity of

learning the new print techniques of lithography, when the first lithograph workshop in Spain was set up in Madrid in 1819 (to be followed shortly afterwards by one in Barcelona). He immediately produced a remarkable series of prints using this process. After moving to Bordeaux, he produced another series, *The Bulls of Bordeaux*, which mark a high point, artistically and technically, in the history of graphics.

In painting too Goya showed himself responsive to the events of his age and ready to express these in his work. Four years before Géricault painted the *Raft of the Medusa* and ten years before Delacroix's *Massacre at Chios*, Goya had painted his reaction to the slaughter of 5,000 Spaniards by the French invaders following Ferdinand VII's abdication in 1808 (*The Third of May 1808*, painted on the return of Ferdinand VII in 1814).

The tragedy of the event is conveyed in a very direct way by the simple, stark and straightforward 'reportage' (a category of art in which an event is rendered factually and accurately) that Goya employs. Faceless soldiers, like robots carrying out the order to kill, take citizens at random for execution, as examples to anyone who would resist Bonaparte's regime (several had tried, hence the executions). Against the backdrop of a sloping hill an illuminated figure resembling Christ crucified awaits the fusillade, some cringe and cover their eyes unable to look while others lie dead in pools of their own blood. Everything is subordinated to the barbarous act of methodical murder.

Goya's genius did not fully thrust itself upon the world scene in his lifetime. One reason was that he was cautious while living and working as a court painter not to do anything that would jeopardise his position. Consequently, many of his most powerful visual statements, such as the *Disasters of War*, were published only after his death. Another reason was the isolation of Spain from the artistic influences of the rest of Europe. Ironically, the images that were generated for him by the atrocities of the French occupation of Spain were among those that inspired French artists of the avant-garde at mid-century and the Surrealists in the next.

2 Sculpture

THE MONOTONOUS MEDIUM

Sculpture had a special role in the art life of the nineteenth century for practical as well as aesthetic reasons. Neoclassical sculptors could copy antique models more closely than could painters, because the permanent nature of stone (very little bronze remained) meant that more of the originals (or Roman copies of Greek originals) survived.

Aesthetically, the revival of ancient Greek forms to express contemporary ideas derived from the eighteenth century's conviction that in the works of antiquity resided the highest standards of excellence and virtue. The Greeks, it was believed, had taken the art of the Assyrians and Egyptians, in primitive and aimless form, and infused into it sense and soul, to create man's highest sculptural achievement; 'they inspired it with heroism, majesty and beauty,' a contemporary critic noted.

In reaction to what they saw as frivolous and irrational in the Rococo style, artists of the period sought to establish aesthetic qualities of truth, purity and nobility such as they believed the finest works of antiquity exemplified. Furthermore, the aim of this revival of antique forms had an ethical mission too, to purify society as well as art. The sculptor was to interpret man's spiritual needs, his most refined feelings, even his vague aspirations, in addition to his ideas of moral and intellectual beauty.

In the expression of man's noblest aspirations, elements of both 'sense' (the real) and 'soul' (the ideal) were combined. A harmonious (not necessarily equal) balance between the spiritual and the sensual was not maintained in all works of art with these aims, but the most successful creations did achieve a fusion of the 'real' and the 'ideal', each reinforcing the other, neither drawing attention to itself. Two examples illustrate this equilibrium, each a statue, each with a distinct aim, both harmonising the real and the

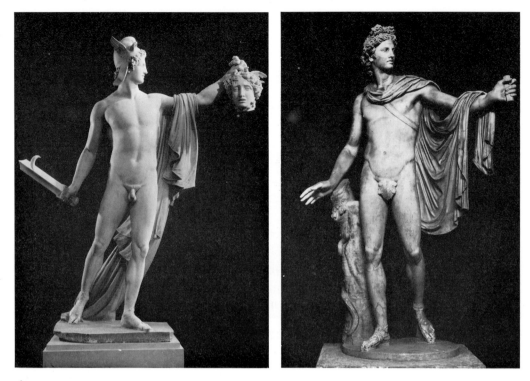

ideal, but each with a different emphasis on sense and spirit, each with a different bond to antiquity.

On the one hand a statue by an Italian artist, deriving his inspiration from a myth of antiquity: Antonio Canova's *Perseus with the Head of Medusa* portrays the popular ancient myth of Perseus, son of Zeus and Danaë, who survived a plot against his life and slew Medusa with the aid of the gods. On the other a work by a Frenchman, the foremost portrait sculptor in Europe, commissioned by Thomas Jefferson: Jean-Antoine Houdon's portrait of George Washington, hero of the American Revolution, symbolises the leadership of the New Republic.

Both statues derive their forms in part from a common model, the *Apollo Belvedere*, which was believed to embody the essence of male beauty (as the *Venus de Medici* was considered the epitome of female perfection), and which inspired painters and sculptors alike. For example, the portrait painters at this time frequently posed their subjects in the *contrapposto* (the pose that expresses movement and life) of the *Apollo*.

In *Perseus*, Canova borrows from the antique figure and takes from ancient literature a theme of courage, duty, and heroic deeds

meant to inspire his contemporaries with a wish to develop such values in their moral and intellectual life. His over-lifesize figure reflects the scale of his antique model and the drapery, theme and idealised handling of the anatomy unmistakably place this statue in the timeless realm of classical mythology.

The human figure was considered the noblest of forms because it was the embodiment of God's greatest creation, the human soul. Contemporary aesthetics held that the most appropriate medium in which to express the figure was sculpture. The marble nude statue was regarded as a sculptural expression of the human soul, and antique sculpture, because of its calm, permanence and uniformity of tone, was considered an especially suitable model for expressing the spiritual and material values that the nineteenth century believed guided its society. (The turbulence and conflict that the myths expressed was either ignored or not fully understood by Neoclassical artists.)

Like the ancient sculptor of the *Apollo*, Canova achieves calm and permanence. The musculature of the left leg that supports the weight of the figure (the engaged leg) is carved to show the same amount of tension as in the right leg (the disengaged leg) which supports no weight; in the same way, in the handling of the face, no particularising effects are employed, no crows' feet around the eyes, or other lines to show human expression. By suspending the laws of nature, the work is transported to another level of reality. Furthermore, the uniformity of tension created by generalised modelling transmits a sense of overall calm to the statue that is read as a metaphor for the presence of the soul (uniformly distributed).

Canova creates a male figure that conforms to a harmony, balance and symmetry that is not found in nature. Like his predecessors in antiquity, Canova creates a figure based on the perfections that nature intended but never achieved in any one individual. Sculptors in the nineteenth century (the idea went back to antiquity) frequently noted that they had seen many a perfect finger but never a perfect hand, many a perfect nose, but never a perfect face. The sculptor, however, through his knowledge of nature and the antique, knew (at least, people believed he did) what nature intended and therefore could create the perfect figure,

or the 'ideal', since it conformed to an 'idea' in the mind of the artist.

Marble, organically pure, free from foreign elements, and permanent, was perceived as the most appropriate medium for the expression of the ideal. Metal was considered appropriate for kitchen utensils but too common and vulgar for sculpture, and the colour and grain of wood made that an unacceptable medium for ideal statuary. Marble, at least of the kind used by sculptors, was called the 'monotonous medium' because its imperceptible grain, smooth texture and neutral colour do not divert the eye from the curves, lines and undulations of the form. The spectator is not distracted by imperfections in the surface which might be associated with corruption and decay. Equally admired, and this may seem to the twentieth century mind to be contradictory, were the rich and varied surface effects and textures which a carver could achieve to suggest human flesh.

It made little difference to even the most knowledgeable nineteenth-century patrons and critics that the ancient Greeks coloured their sculpture and that, therefore, the 'uniformity of tone' they found so appealing was not archaeologically correct. In fact, this actually strengthened the case for the originality and invention of the modern artist, who was creating contemporary sculpture, appropriate to his time and conditions. In other words, he was inspired by the art of antiquity, but he was not simply making slavish copies of ancient statues, an accusation which was sometimes made.

THE TINTED VENUS There were exceptions, of course, to the prevailing sentiments. For example, John Gibson, the English Neoclassical sculptor working in Rome (under Canova and Bertel Thorwaldsen, the Danish sculptor who followed Canova in international fame), produced a Venus in which he applied colour to the marble by means of delicate washes rubbed into the porous surface before polishing. Gibson succeeded, he felt, in coming closer to antique sculpture and also closer to nature in approximating the varied tints of flesh, drapery, and actual materials. Predictably rejected by purists of the 'correct style', his statue generated wide discussion, and acquired the nickname 'The

Tinted Venus', which Hiram Powers, the internationally known American sculptor working in Florence, irreverently re-christened 'The Tainted Venus'.

Although sculptors who tinted their statues were criticised for too closely imitating Madame Tussaud's waxworks, colouristic effects produced by manipulating lighting and environment did not offend the propriety of the 'monotonous medium'. In fact marble, in the wrong light, was considered expressionless. The German Neoclassicist Johann Heinrich von Dannecker's *Ariadne Riding on a Panther* was widely acclaimed by those visiting Frankfurt on the Grand Tour, because of the rosy fleshtones imparted to the white surface by means of carefully managed light. The light conveyed a sense of animated flesh to the figure, which also rotated, for the convenience of the spectator.

Hiram Powers introduced Serravezza marble (named from the town of its origin near Florence where the Serra and the Vezza rivers meet) from the quarries that Michelangelo opened for the Medici in the sixteenth century. Serravezza marble was purer and whiter (and more predictable) than Carrara, in use then, and soon became the most popular marble for the 'correct style'. Its surface was considered especially suitable for the lighting technique that prevailed at the time.

Sculptors insisted that the colour of the walls of the room in which their sculpture was exhibited should be cinammon or deep maroon, reflecting a flesh-like colour onto the marble surface. The light should be soft and diffuse and cast no linear shadows (sharp lines creating geometric forms would conflict with the organic forms of the human face and figure); gaslight was seemly because it animated the surface. For the standing figure or portrait, the light should be elevated enough for the shadow cast by the nose to break just above the verge of the upper lip, allowing the mouth to be seen fully in light and not eclipsed by shadow.

Powers' *Greek Slave*, exhibited first in London in 1845, introduced a new naturalism into the 'correct style'. Through its exhibition there, in France and in America, it became internationally famous and exerted broad influence on Neoclassical sculpture at mid-century. Inspired by the Greek War of Independence (and a thinly veiled reference to the slavery

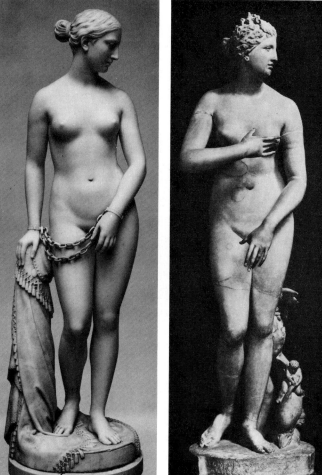

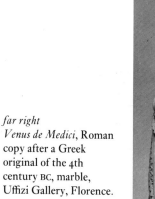

problem in America), the *Greek Slave* draws for its form on an antique source, the *Venus de Medici*, and the sculpture of Giovanni Bologna that Powers admired in Florence, as well as on the figures of the painter Ingres.

Jean-Antoine Houdon borrows from the *Apollo Belvedere's contrapposto* less obviously than does Canova for his lifesize portrait statue of *George Washington* in contemporary dress. Although Houdon wanted to portray Washington in classical drapery, Washington understandably expressed his wish to be clothed in contemporary dress and quoted West's *Death of General Wolfe* as the precedent for his decision. Houdon made a life mask of Washington (now in the Morgan Library, New York) at Mount Vernon, and took casts of his hands, spurs, cane and watch fob to establish an accurate visual record.

This was to be a correct physical record of Washington and would be the model for all representations of him in the future. Houdon united an accurate likeness of Washington with the idea of Washington, conveyed by the antique *contrapposto*, the fasces beneath his left hand symbolic of union, and the sword in its scabbard, an image of peace. Houdon's conflation of the real and the ideal remarkably survived the shifting tastes in statuary. A century later, it was still serving as a model for the statue of Washington by Alexander Stirling Calder (father of the pioneer of mobiles and stabiles) on the Memorial Arch in Washington Square Park in Greenwich Village, New York, built to commemorate the centennial of Washington's inauguration.

The widely celebrated removal of some of the sculpture from the Acropolis in Athens to England in 1806 by Thomas Bruce, Seventh Earl of Elgin (the sculpture now called the 'Elgin Marbles') broadened the century's interest in Greek sculpture. These, from the period before the *Apollo Belvedere*, were more restrained, a characteristic that influenced the leading Neoclassical sculptors of the time. For example, Antonio Canova's seated figure of George Washington of 1818 for the State House of Raleigh, North Carolina, was based on the Dionysus figure from the east

pediment of the Parthenon (*c*. 438–432 BC), one of the Elgin Marbles. Canova had visited England where he studied these treasures at first-hand.

THE UNVEILED SOUL Of the English sculptors working in the 'correct style', John Flaxman exerted a profound and diverse influence. Flaxman's best-known sculptural works are his funeral monuments, for example, the *Mansfield Monument* in Westminster Abbey, and especially the monument to Agnes Cromwell in Chichester Cathedral. Flaxman was an ardent admirer of Emanuel Swedenborg, the Swedish scientist and theologian, whose ideas had an important influence on art in the nineteenth century. The *Cromwell Monument* is one of the first reliefs in which Swedenborg's ideas are fully realised. Flaxman depicts the Swedenborgian teaching that at death the earthly body sheds its materiality (called the 'cutaneous covering') but retains its identity in a 'spiritual body' (in which the soul resides). This monument is important to funereal sculpture in particular, and to ideal sculpture in general, both because of the emphasis Flaxman places on the physical representation of a spiritual being, and because of his elegant relief style. The 'spiritual body' in sculpture Hiram Powers (also an ardent Swedenborgian) called the 'unveiled soul'.

Employed by the pottery manufacturer Josiah Wedgwood,

Flaxman designs for blue and white jasper Wedgwood ware, *c.* 1778: The Apotheosis of Homer (*left*) and the Dancing Hours (*above*).

Flaxman created many designs inspired by antique models for the new ware. 'Wedgwood' became highly popular and Flaxman's designs enjoyed wide circulation, influencing painting, sculpture and the decorative arts. Through his book illustrations for Homer, Aeschylus and Dante, he achieved international fame, and his pure relief-like drawing style served as a rich source of inspiration for artists of succeeding generations, such as David, Ingres, Goya and Runge. His ideas, theories and practices were given additional circulation through the publication of his *Lectures on Sculpture* (1829).

THE ANIMATED MEDIUM

The Romantic sculptor was as committed as the Neoclassical to the human figure, although not limited to marble as a medium; his portrayals were also governed by an appropriate balance between the real and the ideal, and he too drew inspiration from antiquity. However, subjects expressing violent emotion and a style characterised by intense and exaggerated movement often executed in a sketch-like technique distinguish Romantic sculpture from Neoclassical. François Rude's *La Marseillaise* on the Arc de Triomphe in Paris is a good example of the Romantic sculpture of the period, by one of its major artists.

Drawing on Greek and Roman forms, modern sources, and Baroque composition, the sculptor charges a contemporary event with psychological and physical intensity. The French volunteers are taking up their arms and moving swiftly to defend their borders during the Revolution in 1792. Bellona, the Roman Goddess of War, reminiscent of Liberty in Delacroix's tribute to the Revolution of 1830, *Liberty Leading the People*, crowns the massive group of figures she leads into battle. Her left leg extended behind,

37

propels her great winged figure forward, and her outstretched right arm and hand, in which she holds a sword, create a dramatic diagonal that extends the full width of the entire figure group. The motif is repeated below in the soldier's sword at the lower right, the young lad's flexed left arm next to him, and the shoulder and upraised right arm of the figure whose torso and head echoes that of Bellona. The forward movement of this remarkably energetic and deeply carved relief is reinforced by Bellona's empty scabbard flying behind, while the posture of her right leg, repeated in the figures of the soldiers below, establishes a formal unity within the group.

Rude's figures recall Hellenistic masterpieces such as the *Laocoön*, which inspired Michelangelo when it was excavated in Rome early in the sixteenth century. The extraordinary animation of the figures and density of the composition achieved by the exaggeration of gesture and anatomical detail have much in common with the ultra-realism of Hellenistic sculpture. Heads turn, bodies twist, arms and legs entangle according to laws not of this world. Yet the ultra-realistic rendering of detail can lay some claim to be naturalistic. Tightly contained in a shallow space, 'electrified' with a complex pattern of lights and darks, Rude's figures threaten to burst forth from their masonry mooring.

The firm contours and contained surfaces that defined Rude's relief style were softened by his pupil, Jean-Baptiste Carpeaux. His relief group, *The Dance*, shares the spirit of Delacroix's brushwork, and his style anticipates the sketch-like surfaces of Rodin. Comparing this sculpture, commissioned for the facade of Charles Garnier's Opera House in Paris, with Rude's *La Marseillaise*, the eighteenth-century influence is evident in the more relaxed attitudes of the figures, their playfulness expressed in gesture and facial expression. (Carpeaux was also a painter and was influenced by Rococo decoration.) The proportions of the figure are close to those of nature and the modelling of the surfaces approaches the softness of human flesh.

An especially violent strain which runs through Romantic sculpture can be seen in animal groups, like those by Antoine-Louis Barye, a friend of Delacroix, who noted in his *Journal* the emotional power in Barye's bronzes. Barye's *Tiger Devouring a*

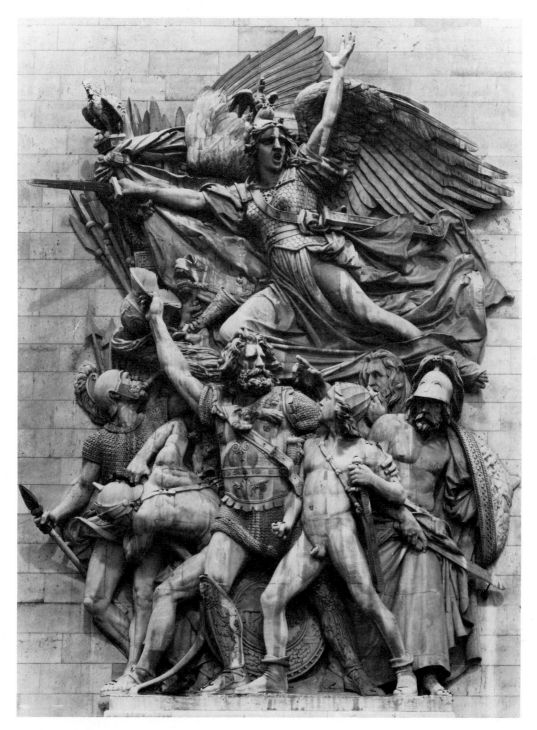

François Rude, *La Marseillaise*,
1833–6, stone, about 13 × 8 m,
Arc de Triomphe, Paris.

Gavial of the Ganges, for which he received a second-class medal in the Salon of 1831, is characteristic of the theme of nature's fight for survival that he expresses with convincing intensity. Influenced by his studies from nature at the Paris Botanical Gardens and by George Stubbs, the English painter who first explored these themes, Barye's small bronzes were consistently favourably reviewed and praised for their fantasy and vivacity. When he taught anatomy at the Musée d'Histoire Naturelle (Museum of Natural History) in Paris, he had a pupil who was destined to become the most celebrated artist of the late nineteenth century and to effect a profound change in the art of the period, Auguste Rodin.

THE ESSENCE OF BEAUTY AND THE LOVE OF NATURE: AUGUSTE RODIN

A poor student by traditional standards, Rodin (1840–1917) could not gain admittance to the École des Beaux-Arts, and studied instead at the Petite École, the Louvre and in the studio of Albert-Ernest Carrier-Belleuse (who has been called the most accomplished master of decorative sculpture of the Second Empire). Their fitful friendship of eighteen years, marked by deep mutual respect, may account for the distinctive tribute Rodin paid his master in 1882, by executing his portrait in Sèvres porcelain, the technique that Carrier-Belleuse revived. This bust is considered one of Rodin's most powerful portraits of the 1880s the period in which his prodigious achievement was gaining recognition.

Rodin's first important work, *The Age of Bronze*, was criticised for being made, it was said, from casts of a living human model. Although Rodin produced evidence to the contrary, including casts and photographs demonstrating how he had departed from his model Auguste Neyt, a Belgian soldier, nothing would convince his critics of the figure's sculptural authenticity. This early rejection of his ideas had a lasting effect on Rodin.

For Rodin, the essence of beauty was life and its highest expression in art was the human figure realising itself through action, even simply walking, as in the sculpture of *St John the Baptist*

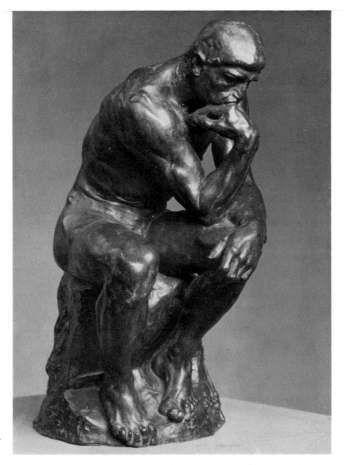

Auguste Rodin, *The Thinker*, 1880–9, bronze, height 70 cm, The Metropolitan Museum of Art, New York, gift of Thomas F. Ryan, 1910.

Preaching, his next significant piece. By portraying both of St John's feet flat and spread apart as in walking, Rodin combined several movements in the cycle of a stride. The right leg and foot suggest the beginning of a stride with heel and toe firmly planted on the ground. It has been noted that the left leg and foot seem to terminate a stride, with leg and foot also firmly planted on the ground flat footed. *The Walking Man*, which served as a model for *St John*, is a torso without arms or head, focussing even more explicitly on the act of walking. Its abstraction makes it especially appealing to the twentieth-century viewer.

In *The Thinker*, man is portrayed in the act of thinking. The figure was originally planned as the principal figure for the *Gates of Hell*, a commission awarded to Rodin in 1880 for a set of doors for the new Musée des Arts Décoratifs for which he selected his theme from Dante's *Inferno* and Baudelaire's *Flowers of Evil*. It has been variously identified as Dante himself, observing the

41

Inferno, or the sculptor, or a symbol of man thinking (which is what Rodin said it was). Although the figure derives in part, formally from Carpeaux's *Ugolino and His Sons* of 1861, the principal sculptural influence comes from Michelangelo, to whom many of Rodin's works are indebted. The brooding quality of the posture is inspired by the figure of Lorenzo de Medici in the Medici Chapel in the church of San Lorenzo in Florence. Michelangelo's figure of Jeremiah in the Sistine ceiling also inspired the posture and such compositional details as the position of the left arm. The torsion achieved by placing the right elbow on the left leg is translated from the symbolic figure of *Night* on Giuliano's tomb which faces that of Lorenzo in the Medici Chapel.

The Thinker has become one of the most familiar art images in the world. It has been reproduced in countless replicas (even for tasteless merchandising purposes), displayed round the world in a variety of institutions (universities, libraries, government buildings), and was chosen by Rodin as his tombstone. It has become a modern-day icon, in that it expresses the human condition through the sculptural interpretation of the human figure.

Rodin believed that art was synonymous with religion and the love of nature; for him, all three were the same thing. His figures united the real (nature) and the ideal (religion) in terms of human nature for the first time. The statue was no longer a surrogate for human expression but an image that embodied the complexities and intensities of man's emotions and feelings.

A Neoclassical Apollo, Perseus, or Venus served to inspire and edify man by means of its association with the moral, intellectual, and aesthetic perfections of antiquity's gods and heroes. Romantic sculpture, more naturalistic in its formal execution, dealt with human feelings as expressed in contemporary, historical or mythological subjects. By mid-century, a growing contingent of critics and public alike was becoming weary of classical language and was ready for fresh images of life that would appeal to 'living hearts and heads'. Rodin's figures made that appeal. Nowhere is this expressed with more profound poignance than in the sea of almost 200 tortured figures in the *Gates of Hell* that are arrayed above, around and beneath *The Thinker*.

opposite
Auguste Rodin, *The Gates of Hell*, bronze, 550 × 370 × 100 cm, Musée Rodin, Paris.

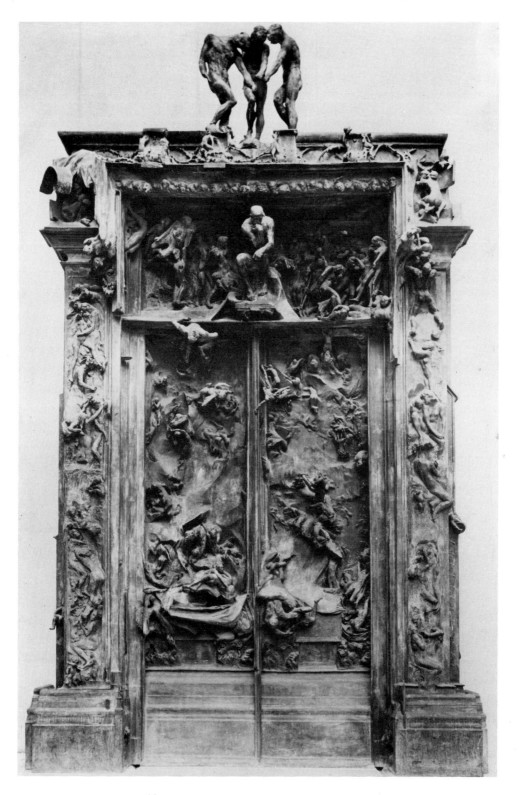

43

The commission was never completed because the government decided against a separate building for the museum. The doors remained in Rodin's studio, and for thirty-seven years, he added, subtracted, and modified the figures and continued to experiment and work out problems of composition, space and expression. The meaning of the sculpture was equally susceptible to change, and except for passages such as *Ugolino* and *Paolo and Francesca*, the overall interpretation remains obscure. The main themes are alienation, despair and death. *The Three Shades* standing on the lintel personify the victory of death (symbolised by the tombs at the bottom of the doors towards which their arms extend), and the futility of man's actions is underscored by the figures beneath demonstrating the varying states of isolation to which man is condemned.

Rodin's sculpture expresses the almost limitless possibilities of the human figure for conveying the subtleties and degrees of man's torment. The depth of the relief ranges from low flame-like undulations, as if merely irregularities in the bronze ground, to fully three-dimensional figures whose arms reach and clutch threatening to invade the spectator's world. The differing scales of the figures mean that the composition has no single vantage point. This reinforces the sense of disorientation and separation that pervades the entire scheme.

The composition is cut by the great portal, like a picture frame, creating the impression that the space occupied by the sea of writhing figures extends beyond the colossal rectangle. Some figures even spill out over the frame. This 'view through' effect was developed in the Netherlands and Italy in the fifteenth century by painters and book illuminators to create a more naturalistic representation of the visible world. No other monumental portal in the history of art has combined the painterly and sculptural properties of illusionism and expressionism as powerfully as Rodin's *Gates of Hell*.

Rodin executed monuments, portraits and memorials in marble as well as in bronze, and they too have been the subject of controversy. It has been charged, inaccurately, that Rodin was not a master of the medium of stone and that he did not finish his stone sculpture himself. Actually, he had worked in stone from his early

years; he understood the medium quite well and could work it. It was common practice for sculptors to employ stone carvers; the master would usually finish a piece of marble (often requiring extensive work), but such functions as 'blocking out' (preparing a stone for fine carving) was time-consuming work that did not require the master's hand and was delegated to assistants.

THE MODERN RELIC Rodin has been credited with inventing a new mode in sculpture – the fragment as a finished work of art. This is also inaccurate because anatomical fragments had been a part of Western art since antiquity. They were very popular as finished works of art in the nineteenth century, long before Rodin made his partial figures and fragments. However, these fragments celebrated in the nineteenth century were either anatomical details of famous statues, such as the foot of the *Venus de Medici*, or fragments that were charged with sentimental significance such as the clasped hands of Robert and Elizabeth Barrett Browning, symbolic of their marital fidelity that was a legend in its own time. Cast in both bronze and plaster versions (the plaster version was actually tinted to flesh tones), that piece was widely known and a number of replicas were produced. This kind of fragment had all the trappings of a contemporary relic and had less to do with art than with private and public devotion. Rodin's interest in the fragment, as with the partial figure (*Walking Man*, for example), however, was in its capacity to express some aspect of the essence of human life. This for him was the foundation of beauty.

3 The Romantic landscape

The Anglo-Chinese landscape garden movement (as it was called) started sometime after 1720 in the circle of Lord Burlington (Richard Boyle) the leader of the classical tradition in England. Burlington, assisted by the gifted and versatile architect, landscape gardener, painter and designer, William Kent, identified the informal gardens of Republican Rome and China (even though the two civilisations were separated by time and place) with their benevolent governments, and their respect for liberty. The Anglo-Chinese landscape garden then was seen to be an appropriate symbol for the freedom that was embodied in the British form of government. Moreover, the spontaneous naturalism of its winding paths and streams and irregular promontories, formed a striking contrast to the geometric gardens of Versailles, which English critics claimed forced nature into a formal straight-jacket, expressive of France's tyrannical form of government.

Claude Lorraine's and Gaspard Poussin's landscape paintings were models for the gardeners such as Lancelot 'Capability' Brown, who fashioned the terrain according to the Claudian formula of framing devices, classical ruins and the like. The term 'picturesque beauty', as used by the Reverend William Gilpin, described the way the landscape garden showed the pictorial qualities of these earlier paintings. The great gardens of Richmond, Chiswick, and Stowe, exemplify the aesthetics of the picturesque that inspired the English poet James Thomson to describe them as '. . . sylvan scenes, where art alone pretends/ To dress her mistress and disclose her charms . . .'

In spite of the political and nationalistic origins of the landscape garden tradition, the dialogue that developed between the notions of the 'picturesque' and of the beautiful and the sublime gave great impetus to painting and literature. Essays and novels dealt with

46

the aesthetics of the landscape. In Jane Austen's *Sense and Sensibility*, Marianne Dashwood wanted to have 'every book that tells her how to admire an old twisted tree'. Sir Uvedale Price suggested modification to Burke's categories of the beautiful and the sublime in his *Essay on the Picturesque*, and Richard Payne Knight offered an *Analytical Inquiry into the Principles of Taste*.

The implication of man's essential integration with nature, the interrelation of nature with man's moods and his aesthetic sense, becomes clear enough in the artists' attempt to express a feeling for the countryside rather than an imitation of it, and to impart a sentiment for specific places rather than for nature as a whole. These concerns are best represented in the works of the two greatest Romantic landscape painters in England, J. M. W. Turner and John Constable.

J. M. W. TURNER: THE LIKENESS AND THE SPIRIT

Joseph Mallord William Turner (1775–1851) came from a family in modest circumstances; he was the son of a barber in Maiden Lane in Covent Garden, who made financial gain from his precocious son's ability to produce picturesque paintings that the public bought. Through his art J. M. W. Turner became financially independent early in his career. He never married. He travelled widely and his travels influenced his painting.

Turner's rise in the Academy was rapid; he became an Associate of the Royal Academy at the age of twenty-four and a Royal Academician at twenty-seven. Turner was made Professor of Perspective in 1807, Deputy President of the Academy in 1845, and because of his business acumen was entrusted to audit the Academy's books. The Academy had supported him in the face of opposition early in his career, and Turner was grateful.

Turner's early works were in the topographical landscape tradition of accurate renderings of actual places. He was influenced especially by the French painter Claude Lorraine, and also Richard Wilson, as well as his friend Thomas Girtin, who in 1799 had founded a sketch club to establish a school of historic landscape in England. Another influence was John Robert Cozens.

Cozens' effect on this generation of painters was enormous, especially through his drawings, which Turner and Girtin copied for the London physician and art patron, Dr Thomas Monro. Monro, who treated Cozens for mental disorders in 1794, was an amateur artist himself, and supported numerous artists to whom he opened his home as a kind of studio.

By the time he was twenty-five, Turner's topographical landscapes were very popular, sold well, and began to give him financial independence. They were in the fashionable 'picturesque' tradition of the English landscape garden.

Between 1805 and 1810, Turner painted a number of oil sketches of views on the River Thames between Walton and Windsor and on the River Wye, in which he records a remarkably immediate presence of nature combined with the reverence appropriate to the 'picturesque'. It has been suggested that this group, the only oils Turner painted directly from nature, may be the first examples by any artist of works completed on the site.

In *Tintern Abbey*, Turner combines a 'likeness' of the structure in the topographical tradition, with dramatic effects of light and dark, which imparts a sublime sense of mystery and awe to the building and the site. William Wordsworth, in 'Lines Composed a Few Miles Above Tintern Abbey, on Revisiting the Banks of the Wye, During a Tour, July 13 1798', recalls his first fascination with the place, five years before, which inspired sentiments of the sublime: '. . . The sounding cataract/ Haunted me like a passion: the tall rock,/ The mountain, and the deep gloomy wood.' Now, in his experience of the place 'revisited', he integrates his feelings for it with humanity: 'For I have learned/ To look on nature, not as in the hour/ Of thoughtless youth; but hearing oftentimes/ The still, sad music of humanity.'

Another writer, Reverend William Gilpin, expressed his fascination with the fleeting effects of atmosphere, always changing but always in harmony, and described the land around Tintern Abbey in *Observations on the River Wye*. This same area was the subject of a view painted by the Academician Philippe-Jacques de Loutherbourg, pioneer of the panorama, and scene painter for the actor David Garrick, London's idol and theatre reformer. De Loutherbourg's operative landscapes, deluges, shipwrecks, and

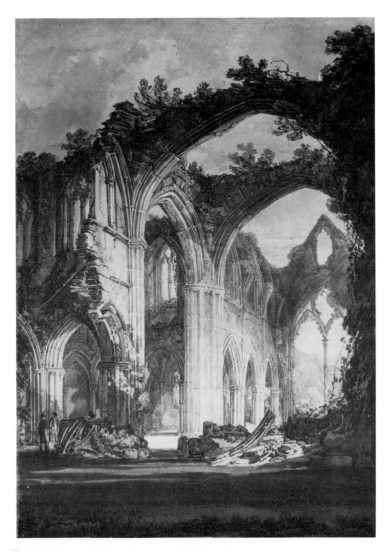

J. M. W. Turner, *The Interior of the Ruins of Tintern Abbey*, c. 1794, 36 × 25.5 cm, pencil and watercolour, British Museum, London.

avalanches influenced Turner's alpine scenes and his large imaginary landscapes of the early 1800s.

Many felt that de Loutherbourg's attempt at actualising natural phenomena to achieve a sublime effect went beyond the boundaries of high art in his *Eidophusikon*, a theatre (with a stage 1.8 metres wide and 2.4 metres deep) without actors that showed 'moving pictures' of storms and the like, complete with coloured lights and sound effects of thunder, lightning and wind. Waves were carved in wood and painted and actually moved and produced foam. Sir Joshua Reynolds recommended his students to see it as the best artificial school of the sublimities of nature.

Turner rejected the theatrical effects and produced spectacles of

immensity, grandeur and tragedy with paint alone. He reveals his lifelong pessimism in the painting that has been called his first masterpiece, *Snow Storm: Hannibal and His Army Crossing the Alps.* The Romantic theme of man's battle for survival against the elements has been translated as man's insignificance in the face of nature's wrath (see pp. 12–13; *Watson and the Shark, Death on the Pale Horse*).

The painting resulted from a number of interrelated experiences, which give some insight into the way Turner worked. The major influence on his early oil paintings had been Dutch marine painting. But in 1802, following the Peace of Amiens, he had gone with the British Academicians to Paris to see the great works in the Louvre. There, he was especially impressed by the works of Titian, Poussin and Rembrandt. The visit also deepened his interest in 'historical landscape' in the grand manner.

Turner then travelled through the Alps, comparing his own firsthand perceptions of its wonders, a key aspect of the sublime, with views of de Loutherbourg and Cozens' renderings of Swiss and Italian landscapes that he had copied at Dr Monro's. Finally, in 1810, Turner was with a friend in a storm on the Yorkshire Moors and he took great pains to record its every changing aspect. Afterwards, he announced to his friend's son that the sketch would, in two years, become *Hannibal Crossing the Alps.*

Turner's flair for accurately recording nature, but especially the sublime aspects of it, inspired him on one occasion to have himself lashed to the mast of a steamboat for four hours during a storm in order to observe it and more importantly to experience the terror it inflicted. The title of the painting that resulted is characteristic of Turner's long titles, some of which contain his poetry: *Snowstorm – Steamboat off a Harbour Mouth Making Signals in Shallow Water, and Going by the Lead. The Author was in the Storm on the Night the Ariel left Harwich.* This fascination with terror, a principal ingredient of the sublime, is a recurring component in Turner's works, dramatically expressed early in his career in *The Tenth Plague of Egypt.*

THE CLAUDIAN FORMULA Another important influence throughout Turner's career was the French painter Claude

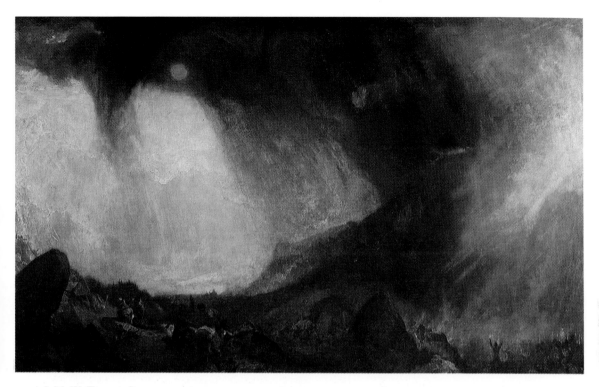

J. M. W. Turner, *Snow Storm: Hannibal and His Army Crossing the Alps.* 1812, oil on canvas, 145 × 236 cm, Tate Gallery, London.

Lorraine. This influence is most obvious in Turner's *Crossing the Brook* of 1814, a painting that almost out-Claudes Claude. To make it clear to posterity that he had indeed surpassed Claude, Turner required that his *Dido Building Carthage* and *Sun Rising Through Vapour* be hung next to two paintings by Claude (*Seaport* and *Mill*) as a stipulation of the bequest of his paintings to the British government, a request still honoured. In *Crossing the Brook*, Turner adhered closely to the Claudian formula: framing devices (called *coulisses*, from theatre nomenclature referring to the side scenes used to frame a central space) enclose the bucolic composition, one large mass of foliage at the right counterbalanced by the smaller mass at the left, low horizon line, recognisable foreground, middle ground and background, soft atmospheric effects of light, a central reflective element (the stream, in this case) that winds its way back into the composition carrying the spectator deeply into the scene, and a classical ruin in the middle ground.

Turner also visited Italy several times. The visits reinforced a growing tendency towards depicting an 'atmosphere' in an almost abstract way. Two works, approximately a decade apart, demonstrate this development. Turner's earlier topographical style is

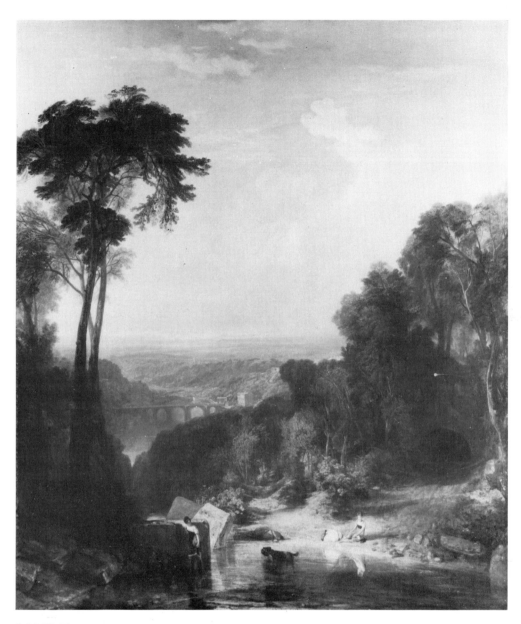

J. M. W. Turner,
Crossing the Brook, 1814,
oil on canvas,
193 × 165 cm, Tate
Gallery, London.

combined with his 'abstraction of atmosphere' in *The Grand Canal, Venice*, while in *Rain, Steam, and Speed – The Great Western Railway*, Turner's painterliness leaves far behind his earlier adherence to the depiction of detail. In this later work, there is no reference left to Claude. All detail gives way to the essential forms of the locomotive and its arched pathway. The steam-driven intruder rushes towards the spectator's space along an ominous diagonal. Turner here dramatises the encroachment of

the railroad on the natural landscape and, although this is in no way the point of the painting, incidentally makes a comment on the changes that the Industrial Revolution was bringing to Britain.

GOLDEN VISIONS AND TINTED STEAM Turner is one of the foremost colourists in the history of Western art. He was to influence the French Impressionists (even though they chose to deny it), and his innovative principles of colour arrangement looked ahead to the colour theories of the twentieth century.

These same two paintings show Turner's pursuit of the colour of light in nature. Through innovative tonal arrangements, he achieves an overall brilliance of tone, greater than that which exists in any individual pigment by itself. Deep tones are neutralised, that is, diluted with white (bringing them closer to grey), light tones are left pure, that is, not neutralised (no white added).

In *Grand Canal, Venice*, for example, the architectural coulisses that frame the canal are predominantly dark, but they are not as dark as they could be, because they have been neutralised, and the warm crimson of the sky is not as crimson as it could be because it has been neutralised. However, the pure hues of broken yellows and oranges that make up the details of the scene are as yellow and as orange as they can be because they have not been neutralised. Against the neutralised fields, these pure tones appear more brilliant individually, and collectively they create a radiance that prompted John Constable to describe Turner's mature paintings as 'golden visions'.

In *Rain, Steam and Speed*, the brilliant passages are concentrated predominantly in the centre of the painting whence emerges the rushing image of the locomotive, as if set off almost like a sculptural relief. In the earlier painting, which depicts more naturalistic detail, the fields of colour are more numerous and more varied; in the later painting, in which less detail is depicted, the fields of colour are fewer and more coherent. Turner's painting continued towards greater abstractions of the natural world's forms and light. John Constable and the critic William Hazlitt agreed that they were painted with 'tinted steam'.

Turner was attracted to Goethe's colour theory, which was first published in 1810 and then translated into English by Charles

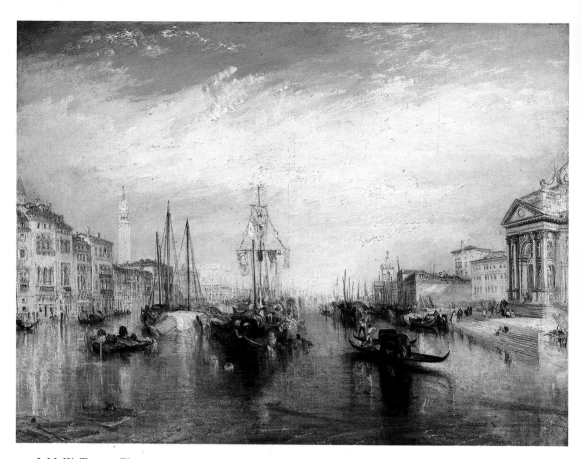

J. M. W. Turner, *The Grand Canal, Venice*, 1835, oil on canvas, 91 × 123 cm, The Metropolitan Museum of Art, New York, Bequest of Cornelius Vanderbilt, 1899 (99.31).

Eastlake in 1840. Goethe differed from Newton in holding that all colour originates from light and dark value and that there are two primary colours – yellow and blue. He identified specific emotions with certain colours, discussed shadows as colour, or transparencies of colour, and explained the active role of the eye in the perception of colour. In 1843, Turner saluted Goethe with a painting: *Light and Colour (Goethe's Theory) – The Morning After the Deluge, Moses Writing in the Book of Genesis.*

The unfinished quality of Turner's paintings offended some and brought sharp criticism from others. One of these was Sir George Beaumont, an arbiter of taste, whose outspoken criticism of Turner's works had a detrimental effect on the sale of his large oil paintings, even though the Academy supported the artist. Furthermore, Turner's works were also criticised for all being the same. To counter the opposition, Turner published between 1806 and 1819 a series of engravings, the *Liber Studiorum*, a compendium of landscape categories: historical, mountainous, pastoral, marine,

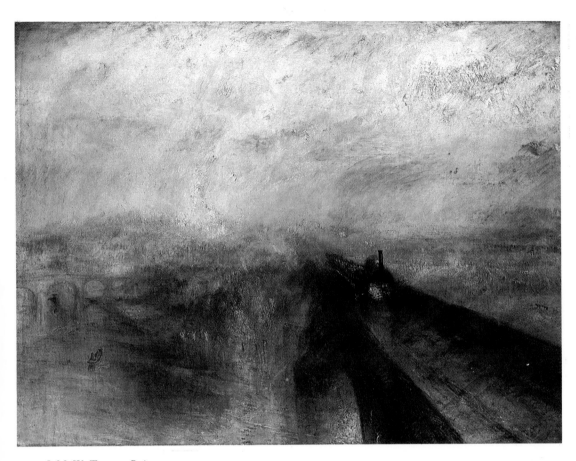

J. M. W. Turner, *Rain, Steam, and Speed – The Great Western Railway*, 1844, oil on canvas, 91 × 122 cm, National Gallery, London.

architectural. It was influenced by Claude's *Liber Veritatis*, though that book was compiled for quite different reasons – as a catalogue of Claude's authentic works. Although instructive, Turner's *Liber* is unfortunately uneven in quality, due to technical problems and Turner not spending enough money on its execution.

By 1843, when Turner's popularity was declining, John Ruskin (1819–1900), destined to become one of the century's most influential critics, published his first volume of *Modern Painters*, whose full title, if lengthy, was in praise of Turner – *Modern Painters: Their Superiority in the Art of Landscape Painting to all the Ancient Masters Proved by Examples of the True, the Beautiful, the Intellectual, From the Works of Modern Artists, Especially from Those of J. M. W. Turner, Esq., R.A., By a Graduate of Oxford.*

As Turner became more reclusive in his later years, his paintings became increasingly focused on his own special vision of light and colour and the possibilities of paint to reproduce it.

55

JOHN CONSTABLE: WHAT NEED TO LOOK BEYOND?

Turner's art was entirely different from that of his contemporary John Constable (1776–1837). He and Turner were never close friends, largely because they were such different personalities and Constable considered Turner uncouth even though he respected his intelligence.

Constable was born in Suffolk in 1776, the son of a successful miller. His art came from the soil upon which he was born and grew up. He had little taste for travel, very much like his father, Golding Constable, who found even his occasional business trips to London 'oppressive journeys, and the air was bad'. Constable claimed that it was the scenes of his own Suffolk countryside that made him a painter. In working for his father, as a youth, he was trained to read the weather and the sky in setting the sails of the windmills that his father owned throughout the Stour Valley. Those windmills found their way into his paintings (*Spring: Ploughing, East Bergholt*) as did the grain-laden boats pulled along the waterways from his father's mills (*Barges on the Stour*) and in *The Cornfield* of 1826, he painted the path he took each morning as a boy on his way to grammar school.

Constable's paintings pose the question, 'What need to look beyond?' Pleasure and lasting reward is in very simple and immediate things, perhaps not fully appreciated at the moment. Even so there is a sense in which Constable's pictures imply that experience looks beyond the present, to recollection, though no more than this. Although he would expect the viewer to look further to a deeper meaning, he was too sophisticated an artist to moralise in his paintings. Rather he gave permanence to his ideas in a series of images that recur regularly in the scenes he painted.

THE HAY WAIN, A LANDSCAPE AT NOON One such recurring image, rooted in the landscape, is Willie Lott's cottage on Gibbon's farm. Lott lived there more than eighty years (until 1849), without ever spending more than four days away. It has been noted that the cottage, which still stands, inspired one of Constable's most important paintings, *The Hay Wain* (first named *Landscape: Noon*) a portrayal of 'fresh water and deep noon-days',

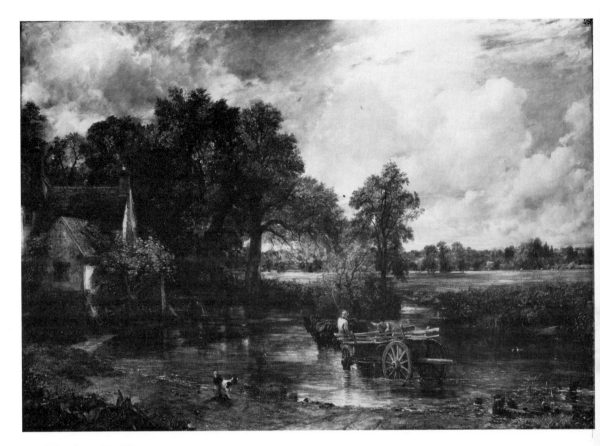

John Constable, *The Hay Wain*, 1821, oil on canvas,
130.5 × 185.5 cm, The National Gallery, London.

for which he won a gold medal at the Paris Salon in 1824. The view he paints is from a small jetty on a platform in front of Golding Constable's Flatford Mill looking downstream across the millrace to Willy Lott's cottage. The painting retains the cottage in the coulisse at the left, which is counterbalanced by an open expanse of sky and land at the right. Constable widened the actual river (as he had also done in *The White Horse* of 1819) to create a broader reflective surface, a larger context for the hay waggon in the lower central part of the painting, and a horizontal emphasis conveying a calm pastoral mood.

COLOUR AND EFFECTS Constable achieved the vivacity and freshness that the artists in France at the Salon of 1824 observed in *The Hay Wain* through rich texture and a wide range of colour learned from his close attention to the surfaces of things in nature (he criticised artists who studied pictures but knew little of nature).

In *The Hay Wain*, Constable reached a new height in his

57

portrayal of nature by retaining the freshness, spontaneity and realism of his first small oil sketch of the subject in large format, an experiment he had first tried in *The White Horse*. This quality of immediacy that one experiences before Constable's mature landscapes has led some observers to see his pictures as portraits of nature.

In 1806, Constable took a sketching trip through the English Lake District in the tradition of the Romantic painters and, like Turner, inspired by the drawings of John Robert Cozens and Thomas Girtin. In spite of his attempt to record the atmospheric conditions there, the mountains oppressed him; it was only the rolling fertile terrain of his home region that interested him, and it was that which he painted for the rest of his life.

In a particularly fertile period from 1813 to 1814, he produced two sketch books that were the source of numerous paintings for many years to come and of an innovative technique, seen especially in *Boat Building, Near Flatford Mill*. He told his biographer and friend, the American painter C. R. Leslie that he had painted this picture entirely out of doors. In this he was to anticipate the Pre-Raphaelites (see chapter 5) and the Impressionists (see chapter 4). The painting shows Constable's inventive use of colour to represent the real world. He demonstrated, for example, that warm colours are not necessary to produce warm effects. Although greys and greens (usually considered cool) predominate, the vibrating quality of warm air is so convincingly rendered that a sense of warmth is produced. Constable kept the painting in his possession his entire life.

We can gain further insight into Constable's attitude towards contemporary notions on colour from an incident in 1823. While visiting Sir George Beaumont at Cole Orton Hall on his estate in Leicestershire, the great patron and amateur painter showed Constable how he tried to match Poussin's tints. Constable replied that time and the countless applications of preservatives over the surface of the painting had changed Poussin's original colours. Nonetheless, Beaumont insisted that the prevailing tone of a landscape painting should be the colour of a Cremona violin. Constable is said to have responded by placing a Cremona violin on the grass to show that nature's colours were quite different.

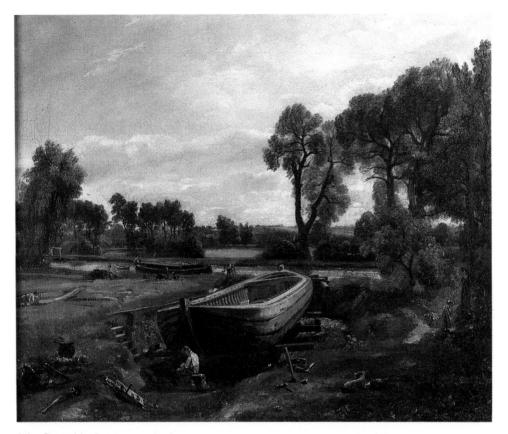

John Constable, *Boat Building, Near Flatford Mill*, 1815, oil on canvas, 50.8 × 61.6 cm, Victoria and Albert Museum, London.

Beaumont's preference for a warm tint also derived from a device called the Claude glass, a dark convex lens (believed to have been developed by Claude Lorraine), which condensed the expanse of landscape viewed through it without losing detail or atmospheric effects. Although used primarily by artists, others found in the Claude glass a rich source of 'picturesque' views on country walks, and using it became quite fashionable. A view through the glass might look like a Claude painting.

The directness with which Constable could address his older host illustrates the close relationship they enjoyed. Beaumont had an affection for Constable and helped the young artist, but he never seemed to see the quality of Constable's talent. Nonetheless, Constable was enormously grateful to Beaumont for letting him copy works in his collection, especially *Hagar and the Angel* by Claude, which he had copied in 1799, and which made a lasting impression on Constable; Claude remained the painter to whom he was most consciously indebted.

In the absence of great public collections such as are common-

place in today's museums, collectors often allowed artists to copy from their private collections. They also loaned their paintings to the Academy for use in painting classes. Constable was able to copy from the works of Annibale Carracci, Richard Wilson, Ruisdael, Rembrandt, Girtin, Poussin and Rubens. From copying great works, artists learned how the earlier masters made and applied pigments, achieved effects, and composed pictures. Patrons often commissioned copies of masterpieces and Constable's unusual skill in this art was noted in his own day.

SKYING Constable was also interested in new investigations into atmospheric effects, and he would probably have known Luke Howard's meteorological work of 1820, *The Climate of London*. Constable came to believe that the sky was the key to landscape painting, because in nature the sky is the source of light governing everything. He often went 'skying', that is, making sketches of cloud formations from nature, then noting the types of clouds, the date and the time of day on the back of the sketch. These sketches were accurate records of nature and served as source material for his paintings.

Although Constable's paintings made little impact on the art of his countrymen in his own time, it had a significant effect on colour and brushwork in French Romantic painting. When Delacroix saw *The Hay Wain* in the Salon of 1824, he re-painted the background of his *Massacre at Chios* (see p. 17), which hung in the same exhibition. What the Academicians in England and France thought of as 'coarseness' or 'roughness' in Constable's manner and arrangement of colour, Delacroix saw as a means of imparting greater life to a composition.

Before long, there were over twenty of Constable's pictures in France, and these also influenced a small but significant contingent of landscape painters who came to be known as the Barbizon School, taking their name from a village at the edge of the Forest of Fontainebleau, where they painted.

This was not an isolated phenomenon; the traffic in art, books, and prints between England and France that dated from the eighteenth century accelerated after the Peace of Amiens (1802). Increased travel and communication between the artists of France

and England resulted in such projects as Géricault's exhibition of the *Raft of the Medusa* (see p. 15) and Louis Jacques Mandé Daguerre's *Diorama*, a scenic production employing translucent paintings reminiscent of de Loutherbourg's *Eidophusikon* (see p. 49). Moreover, in the Paris Salon of 1824, Constable was one of fourteen English artists whose works were included in the great exhibition of over 2,000 works.

Constable watched landscape painting come from a minor genre to a major industry in his own lifetime, and he fought, as Turner and Girtin did, to assure landscape painting its rightful place alongside history painting. The fact that even in France a Prix de Rome had not been offered for historical landscape until 1817 quickened the Royal Academicians in their efforts.

Between 1833 and 1836, the year before he died, Constable delivered a series of six lectures to the Hampstead Literary and Scientific Society in which he traced the long history of landscape painting from Giotto and established its modern origins in the work of Titian. Through this impeccably respectable pedigree, he hoped to assure the proper recognition of landscape painting and his own place in its history. In his last lecture, Constable summed up his life-long convictions that 'painting' was another word for 'living', in the words of Lord Bacon, whom he quoted often: 'It is a great happiness when men's professions and their inclinations accord.'

ROMANTIC LANDSCAPE IN GERMANY

The identification of man with nature is a theme that unites the German painters Caspar David Friedrich and Philipp Otto Runge with the Romantic sensibility. Their closed forms and apparent absences of brushstroke, however, reflect a stylistic adherence to the classical tradition that distinguishes their work from the painterly mode.

Friedrich's paintings are like moments which are crystallised – hushed and transparent – and composed on a carefully structured lattice. Through a set of recurring compositional devices and motifs and the subtle manipualtion of light, his work conveys a

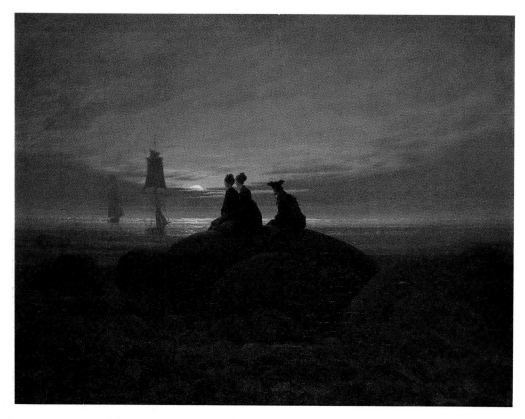

Caspar David Friedrich,
Moonrise over the Sea,
1822, oil on canvas,
55 × 71 cm,
Nationalgalerie, W.
Berlin.

consistent, if alarming, view of life expressed through landscape.
The recognisable foreground, middle ground and background are
laid out parallel to the picture plane in rectangles that isolate a
fragment of apparently infinitely receding space. Moreover, the
frame appears to cut the scene on all four sides suggesting its
continuity beyond the boundaries of the picture.

In *Moonrise over the Sea*, Friedrich portrays a placid sea with
two sailing ships in the middle distance that echo the vertical
figures of two women and a man seated in the foreground who gaze
into the distance with their backs to the viewer. The surface of the
sea recedes in broad thin bands towards the horizon, each thin
ribbon accented by reflections of the moon pillowed behind a hazy
ellipse of clouds above that mirrors the shape of the rocks
supporting the spectators. Sky and water look as if they extend
laterally beyond the confines of the composition, and the sky above
as if it goes on beyond the top of the frame. The extension of the
ground plane below dramatically incorporates the viewer into the
picture space.

In an even more disturbing painting, *Capuchin Friar by the Sea*,

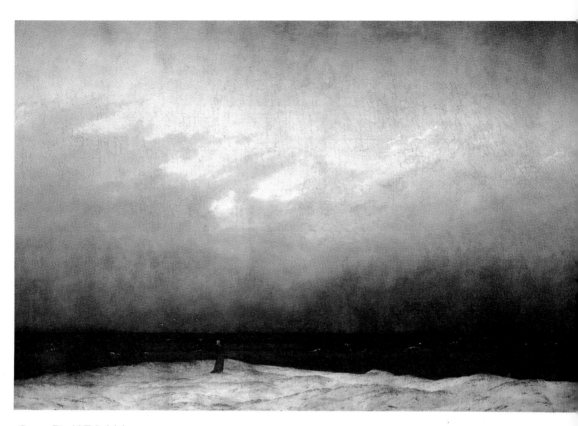

Caspar David Friedrich, *Capuchin Friar by the Sea*, 1808–10, oil on canvas, 110.4 × 171 cm, Schloss Charlottenburg, Berlin.

four fifths of the entire picture surface is sky ominously rendered in delicate variations of grey. The narrow strip at the bottom of the painting defined by a straight horizon line is divided into shapes that fit together like two pieces of a jigsaw puzzle: one, positive and active, the land; the other, negative and passive, the sea.

The dark tone of the sea recedes, the light tone of the land advances. The negative shape (concave and less modelled) and the cool tone of the sea which has a receding effect, moves it away from the viewer into a stark and terrifying void (the deepening grey of the sky at the horizon). The positive shape (modelled, convex and three dimensional) and advancing tone of the subtly undulating land presses it forward beyond the frame as if to extend the ground plane beneath the viewer's feet. The figure of the friar, the single vertical accent in the painting, off centre to the left, unites these positive and negative elements of sea and land, and sets them off against the overwhelming void of the sky above and beyond.

Through the allegory of landscape, Friedrich's art probes the infinite, the boundaries of space and time, and the psychology of man's existence. The complexities of these preoccupations, which

inspired such refinement and power in his paintings, led to painful disorientation in his personal life. He suffered from depression and died in poverty.

Born in a Baltic seaport town in Pomerania, Friedrich studied at the Academy of Copenhagen, and lived most of his life in Dresden, a centre of Romantic music, art, and letters, where he met Runge, who was also from Pomerania and who had also studied in Copenhagen.

Runge was a prolific writer, as well as a painter, and his ideas on nature, vision and colour affected Romantic aesthetic thought as well as painting. He shared ideas on colour with Goethe, who was also in Dresden for a period, and developed a system to study the laws of colour, *The Colour Sphere* (published 1810), which has been the most popular model for colour order systems ever since.

ROMANTIC LANDSCAPE IN THE NEW WORLDS

AMERICA The English landscape tradition found receptive soil in the New World. The first indigenous school of American landscape painting was formed largely on English models and the seventeenth-century European masters that had also inspired Constable and Turner. Thomas Cole, its founder, was born in Lancashire, England, and went to the United States in 1818. When he settled in New York in 1825, and began painting views along the Hudson River, his works gained wide acceptance, and he attracted a following of local artists, who became known as the Hudson River School. Not a school in the conventional sense, its members were a loosely knit group of painters inspired by the Hudson's unsullied landscape. They travelled to Europe to view the famous sites of antiquity and natural wonders of landscape and to see the works of the old masters; some ventured to Central and South America. Their followers later in the century recorded the American West both as independent artists and photographers and as members of US government surveying teams and expeditions.

The early Hudson River style is well represented in *Kindred Spirits* by Asher B. Durand (1796–1886), a successful engraver before he turned to landscape; the composition relies on the

Claudian formula as interpreted by Constable's *Cornfield*. The painting stands as a major icon in the American landscape tradition. Thomas Cole is portrayed with William Cullen Bryant, poet of the American landscape, beholding a view of the Catskill Mountains on a cliff above the Kaaterskill Clove that Cole and his followers had made popular. Durand painted the picture for William Cullen Bryant the year after Cole died, as a tribute to the poet for his moving funeral oration to Cole.

Durand's timing of his salute to Bryant and Cole was propitious for the American landscape tradition. In 1844, Bryant was in the vanguard in calling for a large public park in the European manner. By 1850, enough public sentiment in New York City (sentiment to which Durand's painting contributed) had been generated for a park that it became one of the planks of the political platforms of each contestant running for mayor that year. Central Park was born, the first great American park in the Anglo-Chinese tradition and the model for those that followed. Thirty-five entries were submitted. Frederick Law Olmsted, who as a young man had discovered the picturesque and sublime in the Connecticut countryside, and Calvert Vaux, the English-trained architect working with Andrew Jackson Downing (whose books in the 1840s on landscape gardening were a major influence on American architecture and landscape), won the competition with their design, *Greensward*.

Ten million cartloads of topsoil and twenty years later, the 340-hectare park was a reality, and the principles of the picturesque were given new roots in the New World.

By the mid nineteenth century, a changing attitude toward the role of light produced a new sensibility in landscape and seascape painting that is now called Luminism. Its major proponents included Fitz Hugh Lane (1804–65) and Martin Johnson Heade (1819–1904). They painted clearly ordered compositions whose linear style and predominantly horizontal compositions partly reflected the influences of lithography and photography. The clarity and transparency of the light that acts as the unifying element in their paintings gave the name Luminism to the sensibility that characterises their body of works. Luminism had a profound effect on the Hudson River School of landscape painters.

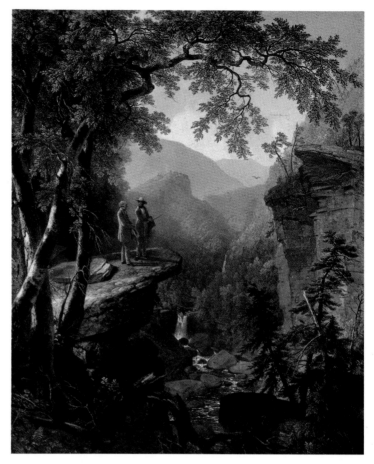

Asher B. Durand,
Kindred Spirits, 1849, oil
on canvas, 112 × 92 cm,
New York Public
Library.

AUSTRALIA Academic painting was nurtured in Australia, ironically, by an expatriate Englishman who was never accepted by the Royal Academy in London, John Glover. Self-taught and a founding member of the Society of British Artists, he was a painter in the topographical landscape tradition whose pictures became highly fashionable in England and brought him financial independence.

At the age of sixty-three, he emigrated to Australia where he painted the bush and lived the life of a country gentleman. Glover continued to send paintings back to London for exhibition until he died in 1849, and he encouraged the development of an indigenous landscape painting tradition in Australia. Others who followed during the first half of the nineteenth century included the Englishman of German descent, Conrad Martens, who arrived in Australia in 1835, and S. T. Gill, who came in 1839. Martens devoted his energies to the life and scenes around Sydney Harbour

66

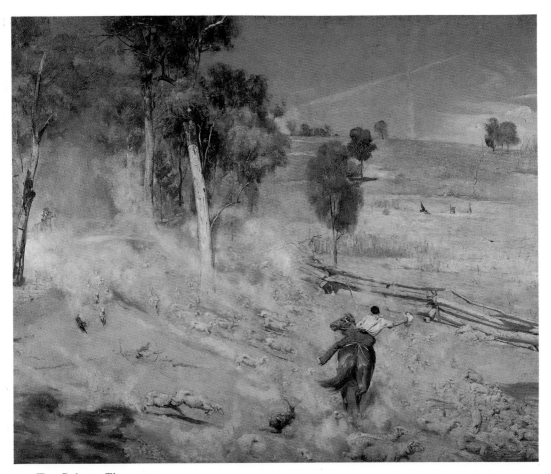

Tom Roberts, *The Breakaway*, c.1890–91, oil on canvas, 137 × 168 cm, Elder Bequest, 1899, National Gallery of South Australia, Adelaide.

and Gill became the artist of the gold fields in the 1850s and 1860s.

Australian landscape painting reached its maturity in the 1880s and 1890s with the work of Tom Roberts, Arthur Streeton, Charles Conder and Frederick McCubbin. They were called 'Impressionists' (although they had little to do with the French Impressionists and their interest in colour theories) because of Roberts' interpretation of the well-known French Academician Jean Léon Gérôme's dictum that in painting the primary concern is the 'general impression' of colour.

Called the father of Australian art, Roberts had studied at the Academy Schools in London, and travelled to France and Spain on painting trips. Inspired by the practice of open air painting, Roberts applied its principles to the Australian landscape.

For Tom Roberts, accurately portraying an impression as it was perceived directly from nature assured a painting timeless and universal validity. That such an expression was a work of art

forever and everywhere was not a revolutionary concept, but it served Tom Roberts as a guiding principle in producing landscape paintings that captured the red and gold land and the azure skies of the Australian bush as never before, and it inspired the other Australian Impressionists to pursue the rich visual treasures of the outback. In Roberts' *The Breakaway*, for example, the blue and gold of the Australian landscape is captured as a brilliant backdrop to the startled jackeroo heading off the stampeding sheep.

The Australian Impressionists often pitched their tents in the bush to paint it as the day broke. The first of these artist's camps in the 1880s was near to Box Hill, a town on the outskirts of Melbourne. Others followed and the Australian landscape school grew. Roberts' visual penetration of the outback revealed its rich pictorial possibilities that have attracted artists ever since.

4 French Realism and Impressionism

Around the middle of the nineteenth century, there emerged a new realism in French painting that had a profound effect on the official as well as the avant-garde art of the period. It came partly as a reaction to the 'correct style' of the Salons (the smoothness of those who followed the techniques of the old masters), and partly as a reaction to the subjective visions of nature and extremes of fantasy of the Romantic view of landscape. At the same time, and more positively, it expressed new interests and a clear-eyed approach that was either regarded as excitingly refreshing or deeply offensive, depending on the point of view. It summed up the prevailing sentiments and convictions of a large group of gifted and committed young artists that it came to serve as a foundation for the first major art movement of 'modern' times, the movement christened (pejoratively at the time) Impressionism.

Two quite different painters were important forces in the creation of the new art, one from the provinces, Gustave Courbet, the other from the city, Édouard Manet; and their painting was as different as they were.

GUSTAVE COURBET

Gustave Courbet (1819–77) was born into a family of well-to-do landowners at Ornans, a small French town near the Swiss border. After studying art in Besançon under a follower of Jacques-Louis David, Courbet settled in Paris in 1840, where he attended the Académie Suisse and drew at the Louvre. In 1844 he entered a self-portrait in the Salon, and in 1849 he won a medal for *Afternoon at Ornans*, which was then purchased by the state.

In technique Courbet learnt largely from Velazquez and Zurbarán, from Rembrandt and Franz Hals in his handling of paint and interpretation of light and shade, and from David in

69

regard to composition and the depiction of space. But his subject matter, the portrayal of provincial life, set him apart from the academicians (the Ecole des Beaux-Arts was the official government school of art, or Academy, and its members were called academicians). Courbet was also distinguished by his painterly technique in which he differed from contemporary naturalists who meticulously depicted illusionistic detail.

Courbet believed that artists should paint only what they could experience with their senses – the persons, places and things that actually existed in their own surroundings. The reason he never painted an angel, he said, was because he never saw one. At the same time, he had a passion for the materiality of nature – textures, masses and the stuff of which the world is made. These hallmarks of his painting (which became characteristics of what came to be called 'the new Realism' can be seen in *The Village Maidens*. A rich impasto in the handling of the cliffs gives a material texture to their geological forms. To emphasise certain passages of rocks and grass, Courbet allows natural light to fall upon them, even though the light source is not consistent. The spatial relationship between foreground and background goes against the rules of traditional perspective and thereby emphasises the figures and the landscape masses in the paintings. Light reflections and dark shadows identify the underlying geological composition peculiar to the Valley of the Loue where the artist grew up; and by means of heavy impasto painted with broad brushstrokes, thickly and irregularly applied, Courbet presents an image of that landscape that is an expression of its essence rather than a depiction of its superficial attributes. Courbet's analytical response to the structure of the landscape anticipates Cézanne's approach to landscape in the later nineteenth century (p. 124).

To appreciate *The Village Maidens* fully, the painting must be seen in the context of contemporary society. At the time this picture was painted, Europe was overwhelmingly a rural society, and one in which people did not move around much; 88% of the French population lived in the *département* of their birth. Illiteracy was widespread; a quarter of the population could not speak standard French, but only their local patois. In rural areas, there was severe poverty. Inadequate diet, lack of pure water supplies and poor

Gustave Courbet, *The Village Maidens*, 1851, oil on canvas, preliminary sketch, 54 × 66 cm, City Art Gallery, Leeds.

hygiene (the peasants lived at close quarters with their animals) led to diseases and high death rates among the peasant class.

Through careful juxtaposition, Courbet makes a social statement in *The Village Maidens*, in which he employs formal elements to reinforce his message. Three maidens (his sisters were the models: from left to right, they are Zoé, Zélie, and Juliette) from the town are pictured giving alms to a young peasant girl tending her cows. The familiar geological formations of the Loue Valley form a backdrop to this scene. The composition echoes the elliptical surface of the pond balanced by the groups of people and cows at the left and right, carefully though casually circumscribed by the pathlike forms cut into the natural terrain. The volumes of the figure group to the left are convincing through naturalistic modelling, greater variety of colour and long shadows cast by the figures. They contrast with the spatial compression (punctuated by the tree that extends upwards from the vertical axis of the

pyramid formed by the figures) of foreground and background and the more two-dimensional rendering of the cows to the right. These animals are not drawn in a naturalistic way and cast no shadows; they create a dramatic contrast between figure and ground.

The figure group to the left stands in modelled relief against the landscape, while the figures to the right lie flat on the canvas, this device serving to draw attention to the maidens' charity towards the little girl. We now recognise this sophisticated use of formal landscape elements to reinforce the social significance of his painting as especially effective, but in Courbet's time critics saw his picture as ugly and vulgar. They disapproved of his rejection of traditional landscape composition. His refusal to populate his space with ideal figures or historical subject matter brought sharp criticism in the Salon of 1852.

In 1855, the year of the International Exposition, although the jurors accepted a number of Courbet's paintings, they rejected two which he considered most important: *Burial at Ornans* and *The Artist's Studio*. This angered Courbet to the extent that he decided to construct his own pavilion; he exhibited over forty works in his *Pavillon du Réalisme*, and from then on, Realism was synonymous with Courbet's name.

COURBET'S MANIFESTO Exhibiting the *Studio* was particularly important for him, because the painting summed up his ideas, both formal and iconographical, as he stated in the subtitle: *A Real Allegory of Seven Years of My Artistic Life*. Courbet presents his manifesto in the form of a contemporary *sacra conversazione*, a 'holy conversation', a format developed from triptych altarpieces in Italy in the mid-fifteenth century; the use of this form suggesting associations with traditional Christian iconography. In this tripartite composition, three levels of the society of his day are portrayed: on the left, the outside world including a merchant, a worker and his wife, a hunter and an old man; on the right, the world of the arts and the Salon populated by friends and acquaintances of the artist including Champfleury, Proudhon and Baudelaire; and in the centre, the world of the artist, including Courbet, his model and a child. Consistently with his other works,

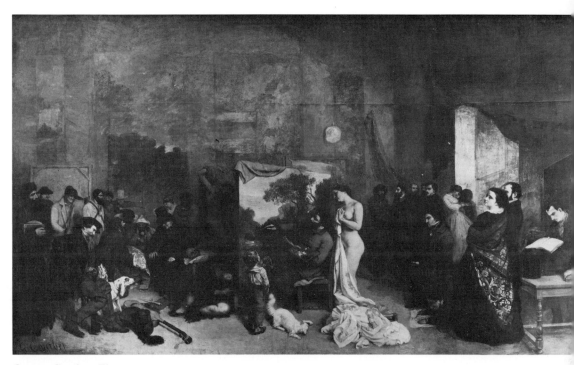

Gustave Courbet, *The Artist's Studio*, 1854–5, oil on canvas, 360 × 597 cm, Louvre, Paris.

Courbet uses light to identify and model his faces and figures without showing any actual source of light.

By means of alternating effects of light and dark, he arranges his forms in a frieze-like fashion along the bottom half of the composition beneath a curious and indecipherable wall surface that acts as a foil to the weighty mass of figures below. If we examine the central group, we discover a modern adaptation of the ancient theme of the ages of man. The nursing figure group of the mother and child (to the left below Courbet's easel), representing infancy, begins the cycle. Reading from left to right into the central group, the small boy represents the next stage, childhood; then the artist and his model with a landscape painting, mounted on an easel, represent the adult stage of man and the principal focus of the picture. Behind the artist's canvas, on the axis with Courbet's figure, the martyred St Sebastian completes the cycle of life. The skull at his feet links the saint to the seated undertaker and the world that occupies the left panel of which he is a part.

Three female figures on different planes in the picture, representing the levels of reality they occupy, unite the three worlds formally and iconographically: in the left group, the worker's wife in the background behind the undertaker faces out; the artist's model in the central group in the middle ground faces

73

in the wife's direction; and the woman from the Salon in the foreground of the right group also faces from the right to the left on a diagonal line into the composition.

The focus of the painting is Courbet and his canvas, the pivot of the composition. Placed at an oblique angle to the picture plane, the canvas links the foreground to some kind of a background wall. Its position is established only by means of some vague forms that seem to hang on or in front of it and against which Courbet displays his figures as if in classical relief.

The pivotal role that Courbet's canvas itself plays in the composition extends also to the landscape painting on the canvas. That he can paint a landscape scene without either seeing the scene itself in reality or using sketches of it underscores the importance Courbet places on the creative power of the artist. For Courbet, the artist, and the act of creation in the studio, occupy the highest level of reality. Nonetheless, to identify what is reality and what is allegory in *The Artist's Studio* requires more evidence than Courbet chooses to give the spectator.

Courbet's 'manifesto', as it was expressed in his paintings, kept a feeling for the real life situation, for the human story; this, with his technical departures, contrived to offer a very different vision of the role of the artist and art to that expressed in the 'official' art of the period, as exemplified by Ingres.

EDOUARD MANET

Another and somewhat different alternative to the 'official' art presented itself in the work of Manet. Edouard Manet (1832–83) came from a well-to-do bourgeois family in Paris. He studied painting with Thomas Couture, a leading portrait and history painter and one of the most influential teachers in France in the second half of the century. Manet's career was shaped by his ambivalent allegiance to the academic tradition, on the one hand, and to his own individual brand of the new realism, on the other. He wanted professional recognition and financial success, which could only be attained through acceptance by the Salon, and acceptance by the Salon jurors could only be assured by

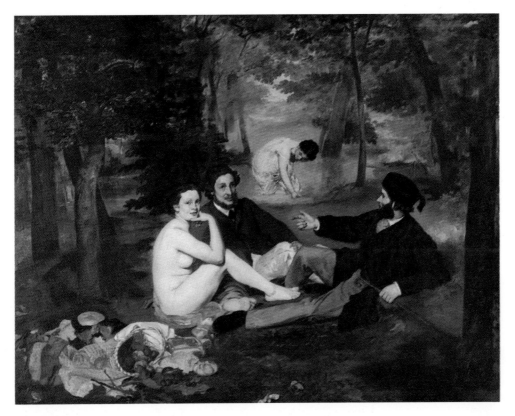

Edouard Manet,
Déjeuner sur l'herbe,
1863, oil on canvas,
215 × 270 cm, Louvre,
Paris.

conforming to the 'official' style. It is true that by the time Manet was painting, there was a greater flexibility in Salon standards, yet still the restrictions in style and subject matter were confining for many young artists. Manet tried to keep a balance between the old and the new which would be acceptable to the Salon and would at the same time allow him the chance to express his own ideas. But the wish to experiment and express his own ideas was strong enough to prevent recognition and success in the early stages of his career.

The Spanish Singer (later called the *Guitar Player*) won Manet honourable mention in the Salon of 1861, and high praise from the influential critic Théophile Gautier. This gave him the kind of recognition that was most useful to a young artist and promised well for the future. The portrayal of an itinerant musician was a well known theme not only of the avant-garde painters but also of the admired masters. Courbet had exhibited a *Guitar Player* in the Salon of 1845, and there were many easily recognisable sources for this kind of painting in Spanish and Dutch art especially; this pleased Gautier. While the rich, dark tones recalling Velazquez,

Goya and Hals appealed to the critic, Manet's straightforward and down-to-earth realism gave a freshness to his rendering that set it apart from its predecessors in Spanish and Dutch painting. At the same time, the strong contrasts between lights and darks and the traditional practice of building up the paint surface to a beautifully rendered finish reflected Manet's academic training under Couture. The picture, then, united a characteristically academic technique with Manet's personal interest in the new realism; but the balance was not to be sustained.

Manet began to depart more noticeably from official standards and his works drew severe criticism. However, he continued to submit works to the Salon, believing that any painter's career had to be built up through that outlet. Finally, the year before he died, after having exhibited *A Bar at the Folies-Bergère* in the Salon of 1882, he was nominated to the Legion of Honour. But he felt the recognition came much too late, and he was bitter.

DEJEUNER SUR L'HERBE One of Manet's most controversial paintings was *Déjeuner sur L'Herbe*. In 1863, he submitted it to the Salon jury, who rejected it. However, because the jury was especially strict that year and rejected the works of many artists whose works were usually admitted, Emperor Napoleon III intervened in the proceedings and had the rejected works exhibited separately in another part of the Palais de l'Industrie (where the Salon was held at that time). The exhibition was called the Salon des Refusés, the salon of the rejected works. Manet's painting was listed in the catalogue as *Le Bain* (*The Bath*).

Neither the emperor nor the critics liked it for reasons of both content and style. Although the critics noted the similarity in composition to the *Fête Champêtre* in the Louvre by the Venetian Renaissance painter Giorgione, they felt that Manet's painting paled by comparison with its Renaissance predecessor (Giorgione's subtle use of colour was considered to be far superior). The modern work shocked contemporary sensibilities by placing nude females next to clothed males in what was considered an indecent manner. Shocking too, was the way in which Manet painted the piece, because the spectators missed the subtle references to earlier masters in this composition.

It is significant that Manet borrowed from the Renaissance not only a well-known subject but also devices of composition involving interpenetrations of arcs and triangles in different planes that have their origins in the paintings of Giotto in the fourteenth century and that reached a sophisticated degree of development in the sixteenth century in Italy.

In *Déjeuner sur l'Herbe*, Manet portrays four figures, Victorine Meurend (a favourite model), Eugène Manet (his brother), Ferdinand Leenhoff (a sculptor, and his future brother-in-law), and a stooping Venus-like figure and a still-life in a landscape. He arranges the figures by means of a series of sophisticated interpenetrating triangular patterns.

Manet's central figure group was influenced by an engraving after Raphael by Raimondi. The right arm and elbow of Victorine framing a dark void, does not rest on her knee as in the figure in Raimondi's engraving, however, nor does her forearm recede, as it would if naturalistically foreshortened. Instead, Manet creates a flat triangular form that holds to the surface of the picture plane. The elbow slips down overlapping the knee and engages the apex of a small triangle that frames the bottom of Victorine's emerging bare sole vertically linked to the dark shoe of Ferdinand.

This light and dark motif created by sole and shoe, which Manet employs with considerable consistency (see the *Fifer*, p. 79: the figure's black shoes and white spats, rendered with minimal modelling, keep the form on the surface of the picture plane), is echoed in Ferdinand's hand and drapery. The motif in both cases rests at the base of the vertical axis of a small triangle whose apex points to the head of the male figure behind the triangle. The two small triangles slightly overlap each other on the picture plane and share a common base with a larger triangle that organises all four figures within the landscape. The brilliantly coloured bullfinch, placed at the top and centre of the composition, against a panoply of branches which lie on different spatial planes, is the apex of the larger triangle.

Triangular patterns bind the composition in depth also. Plotting the position of each of the four figures in the landscape reveals that these same triangular patterns are repeated perpendicular to the picture plane. Eugène's figure at the left of Victorine's forms the

apex of a triangle formed by the three figures in the foreground. Moreover, the stooping Venus-like figure in the middle ground forms the apex of a triangle that contains all four figures.

These interconnections are reinforced by the frieze-like composition of the foreground figures. Victorine's right hip and Ferdinand's left hip and elbow occupy the same plane. His right foot and her left knee, as well as his left knee and her right knee are tightly intertwined within the same plane.

Through the intertwining limbs (that formally lock the foreground group into the picture plane) the erotic significance of the painting is stated. Manet clarifies this meaning by handling Ferdinand's upraised hand, his left hand, and Victorine's emerging left sole identically, in texture and tone. He illustrates the focal position occupied by Ferdinand's upraised hand, the apex of an anatomical triangle. It has been pointed out that Ferdinand's right forefinger is extended as a perch for the bullfinch, traditionally a symbol for promiscuity. Therefore, the formal centre of the picture and its central meaning are united in this anatomical configuration with the symbol that explains it.

Manet lamented that his contemporaries missed the point of the painting. Instead of seeing the richness and sophistication of Manet's art, and the formal innovations of his style, they saw coarseness, vulgarity and crudity. Manet's erotic images ennobled by formal devices conspired to stimulate and delight the whole person – body and spirit. However, it would take time for his message to be understood – unfortunately that would not be in his own lifetime.

THE COLOUR PATCH In the broad flat areas of colour (especially in the central figure group), Manet rejected the academic technique of building up the paint surface to an appropriate finish and of modelling his forms three-dimensionally. Although he employed the traditional contrasts of darks and lights as in the *Spanish Singer*, the forms in *Déjeuner sur l'Herbe* are much more simplified, less linear, and very thinly painted. These qualities were unacceptable to most academicians. In the landscape background, for example, the foliage and the reflections on the water are merely suggested by loose brushwork; still other forms,

Edouard Manet, *The Fifer*, 1866, oil on canvas, 160 × 97 cm, Louvre, Paris.

such as the bank of the stream in the centre of the composition and the tree trunks (especially those at the left of the composition) are defined by tonal contrasts in a painterly way. Manet's flatness prompted Courbet to compare Manet's figures to those on playing cards.

Manet's innovations in composition, interpretation of space, and handling of the pictorial surface were to some extent influenced by the widespread contemporary interest in the Japanese woodcut, with its elliptical perspective, linear patterns, asymmetrical compositions and subtle tonal gradations. His *Fifer*, painted in 1866, is a good example.

79

The *Fifer's* flat shallow image is locked into the picture plane by means of the arrangement of broad colour patches of his uniform and fleshtones. Subtle modelling of the undulating contours that contain the figure render its silhouette as a rounded edge relieved against a cool ground parallel to the picture plane. The shadow cast by the boy's left foot only suggests position and distance; otherwise, it is not clear where or on what the boy is standing. These elements work together to create an image that hovers as if suspended between the picture plane and the ground, an image that virtually creates its own space.

Another source for the flatness of the images that Manet created and the thinly painted forms, as well as the traditional composition devices that Manet employed, is found in the academic sketch. A student's training at the Ecole des Beaux-Arts included making numerous sketches as an integral part of developing a painting. Sketches served different purposes and began with the *premiere pensée*, a quite spontaneous sketch whose purpose was to record an idea, or basic pictorial data, in its most rudimentary form. From this initial step, further sketches were directed towards developing and refining the original idea more fully, and each sketch had a specific purpose. The *ébauche* was an oil sketch (it sometimes served as an under-painting) that embodied the general composition and the arrangement of the colour and tones thinly painted in a broad, flat technique.

Manet, then, drew on a wide range of sources from the past and from the present in developing an independent style that had an enormous influence on contemporary avant-garde painters as well as artists of succeeding generations. His technique derived from the academic tradition, whose principles could be traced to the Renaissance, and his ideas of composition, notions of form and colour, interpretation of space and attitude towards the picture surface emerged from his response to the old masters and contemporary influences.

Courbet and Manet contributed much to the liberation of painting from academic restraints, not only through their art, but also through their exhibition of it. Courbet's independent exhibition of 1855 and his and Manet's independent exhibition of 1867 were models for the Impressionists in the 1870s.

THE CAFE AND THE ATELIER

Open, frank and lively discussion about painting, sculpture, literature and criticism took place in one of the most important forums in the nineteenth century for free exchange of ideas, the café. Some cafés were known for the groups that frequented them. Courbet and his associates were to be found at the Brasserie des Martyrs and Andler Keller. Manet and his friends met at the Café de Bade, and by the mid-1860s at the Café Guerbois. It was to these gatherings of Manet's circle that some of the young painters later to become known as the Impressionists came to discuss ideas.

These young painters received their training in the ateliers of masters or practitioners who, for a fee, supplied space, models and instruction. Two of these ateliers, Atelier Gleyre and Académie Suisse, attracted some of the more familiar names. The atelier of Charles Gleyre, where Claude Monet, Frédéric Bazille (killed in the Franco-Prussian War), Auguste Renoir, and Alfred Sisley studied, appealed to these young artists because of Gleyre's own interest in pure landscape. He had been a friend of Richard Parkes Bonington, the English landscape painter who studied and painted in France, and he encouraged his pupils to paint landscapes. He also advocated painting *en plein air*, which was practised by many academicians. Although he was not an academician and did not teach at the Ecole des Beaux-Arts, Gleyre supported traditional academic practice, especially as it applied to sound techniques: setting the palette, mixing paints, proper use of brushes. But he encouraged originality of expression and, while he favoured academic principles, he did not insist that pupils follow his advice in all things. In some ways, then, he combined the old and the new. His atelier offered the young artist a place to work, a model and instruction from the master on a regular basis, and his fee was lower than that of other studios.

THE IMPRESSIONISTS

The painters Bazille, Sisley, Renoir and Monet were in Gleyre's studio about the same time in 1862, and became a close-knit

group, no doubt because of their common interest in painting from nature, but also probably to defend themselves against the hazing that was customary in these ateliers. (Newcomers were subjected to intimidation by bullies, sometimes severe enough to cause a studio to be shut down.) They also painted together at the Forest of Fontainebleau, the home of the Barbizon painters (chief of whom were Jean François Millet, Théodore Rousseau and Narcisse Virgile Diaz de la Peñã).

Among the formative influences on the Barbizon painters were the works of Camille Corot, the Dutch seventeenth-century landscape painters (especially Jacob van Ruisdael and Meindert Hobbema), John Constable (p. 60), and Richard Parkes Bonington. Although some of their paintings tend to glorify peasant life, others reflect a direct observation of the natural landscape, free of genre and mythological or biblical narrative elements. In this they had a direct influence on Monet and his friends when they assembled at Barbizon in 1865 to paint with these masters of landscape.

Other artists such as Camille Pissarro and Paul Cézanne, who would also be called Impressionists, attended the Académie Suisse, an atelier with less structure than Gleyre's studio, established by a former model who offered space, a model and some instruction in drawing. It was quite popular, very free and lively, and virtually every artist of the period worked there at one time or another. Gleyre had also worked there and it was there that he met Bonington. Because of the informal atmosphere, it offered an opportunity for artists to assemble, work and freely exchange ideas.

Berthe Morisot was the first woman to join the Impressionists. Like Pissarro, Morisot became a pupil of Corot, whom she met in 1861 when he was painting landscapes at Ville d'Avray near Paris.

Jean Baptiste Camille Corot studied with Michallon and Bertin, then travelled to Rome in 1825, 1834 and 1843 where he painted historical sites and the Italian landscape, which had a lasting effect on his interpretation of his native French landscape. Through innovative techniques, Corot developed a style of subtle tonal contrasts that became very popular in his Salon exhibits. Poetic in mood, these pictures were described by Mrs Cheveley in

Jean Baptiste Camille
Corot, *The Bridge at
Narni*, 1827,
68 × 94.5 cm, National
Gallery of Canada,
Ottawa.

Oscar Wilde's *An Ideal Husband* as 'silver twilights' and 'rose-pink
dawns'. A selection of these soft, poetic paintings was used by the
Ballet Russe in its productions of *Les Sylphides*.

Even though Corot was a successful and popular Salon painter,
many of his works, not painted for his Salon exhibits, are among
the most innovative of his time. For example, *The Bridge at Narni*
of 1826–27, in its handling of colour, composition and brushwork,
is very like an Impressionist painting of the 1870s.

Not only was Corot influential on the new movements, but he
responded positively to the experiments of younger painters and
individually encouraged the new realists of the 1850s and the
Impressionists of the 1870s, even though, in his distaste for
factions, he gave them no official support.

Mary Cassatt was invited to join the Impressionists by Edgar
Degas whom she met in 1877. An American, born in Pittsburgh,
she studied at the Pennsylvania Academy from 1861 to 1866,
thereafter settling in Paris in 1868 to study painting. At approxi-
mately the same time that Cassatt was invited to exhibit with
the Impressionist group, another artist, Paul Gauguin began
studying with Pissarro.

83

One of the ablest, curiously complex and most influential of the Impressionists was Edgar Degas (1834–1917), from a well-to-do Paris family, who gave up studying law in order to become a painter.

Degas met Ingres when he was a young man and always remembered Ingres' advice to 'draw lots of lines'. He entered the Ecole des Beaux-Arts in 1855, the year Ingres was given the retrospective at the Exposition Universelle, and he studied under Louis Lamothe, a pupil of Ingres. From Courbet he learnt about colour.

In draughtsmanship, he was influenced by a very different kind of artist, Honoré Daumier, who is today known mainly as a caricaturist and social and political satirist of great bite and power, but who was also a painter. Daumier had a marvellous capacity for distilling the essence of human facial expression and bodily gesture, as in *Les Papas* (lithograph, *Le Charivari* 1846) and *Posant en membre du comice d'Agriculture de son département* (lithograph, *Le Charivari* 1865). Even in Daumier's best paintings it is the expressiveness of his drawing and his sense of design that set him apart from his contemporaries. *Third Class Carriage* is one of the best examples of his vivid commentaries on the human condition; looking at this picture, one can see why he held such an appeal for Degas.

In the early 1860s, Degas met Manet, who was pleased to find a painter with a similar social background and compatible cultural interests. The two artists soon became good friends, and Degas went frequently to the Café Guerbois.

Monet, Renoir, Pissarro, Sisley and Bazille were fundamentally landscape painters, whereas Degas was not. When they first decided to exhibit on their own, independently of the Salon, in 1874, Degas insisted, for purposes of getting started, on broadening the base of the participants to include artists who also exhibited in the Salon in order to offer a wider appeal to the public. Degas won his point; they organised under the name *Société Anonyme des Artistes Peintres, Sculpteurs, Gravures*, and enlisted over 160 works of art for that first exhibition which was opened in April.

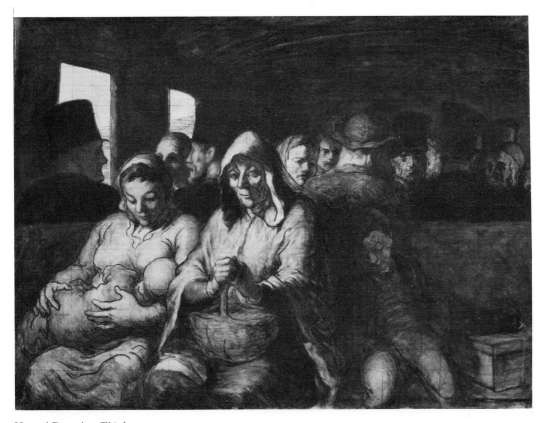

Honoré Daumier, *Third Class Carriage*, *c.* 1862, 66 × 90 cm, The Metropolitan Museum of Art, New York, Bequest of Mrs H. O. Havemeyer, 1929 (29.100.129), the H. O. Havemeyer Collection.

THE IMPRESSION The critic Louis Leroy entitled his review of the exhibition, published in *Le Charivari*, 25 April 1874 'Exhibition of Impressionists'. The word 'impression' was already a well-known and widely used one. It had been used both broadly and narrowly by the painters of the avant-garde themselves talking about their works as well as by the critics of the period to describe the sketch-like and unfinished quality of an artist's work. Manet spoke of trying to convey his impression.

The critic Castagnary as far back as 1863 had written that with the painter Johan Barthold Jongkind, everything lies in the impression, referring to how his subject appeared to him and the atmospheric quality that he sought to capture. The critic Albert Wolff in 1869 had said that one does not paint a seascape, or a figure, one paints the impression of an hour of the day. Critics had used 'impression' to describe the paintings of Corot and Daubigny as well.

In the broad sense, the word was used to refer to the initial visual impact an artist received when looking at the subject matter for a painting. In this sense, it was also used to refer to the overall

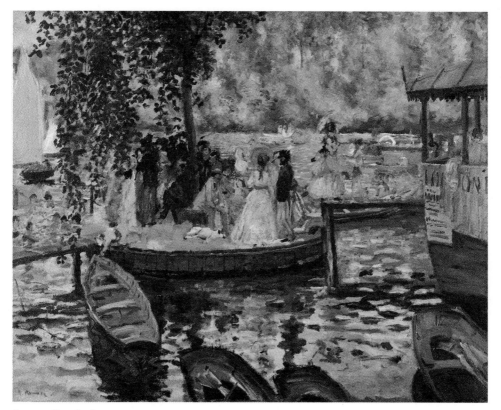

Auguste Renoir, *La Grenouillière*, *c.* 1869, oil on canvas, 66 × 81.3 cm, Nationalmuseum, Stockholm.

effect that the artist succeeded in capturing on canvas. In a narrower and more precise sense, 'impression' was used by the Academy synonymously with *première pensée*, a quick spontaneous sketch. In the academic tradition, the sketch was always seen as a step toward the finished painting. Therefore, exhibiting a painting that looked to the critic like a sketch, was seen as a lack of regard for the academic standards of correct drawing, form and finish.

Louis Leroy saw the exhibition of 1874 as a large collection of 'impressions' (some were even named impressions; Monet's *Impression, Sunrise*, for example) and as an anti-academic display hostile to and defiant of the official art of the Salon. Critics had long decried the unfinished quality of the works of avant-garde painters. The title of Louis Leroy's review had associations both in the academic and the popular mind, and it turned out to be a label that was to endure.

Although the work of the Impressionists grew from that of the Realist painters, it was different in a significant way. The Impressionists were fundamentally interested in accurately portraying their perception of the natural world as they saw it without

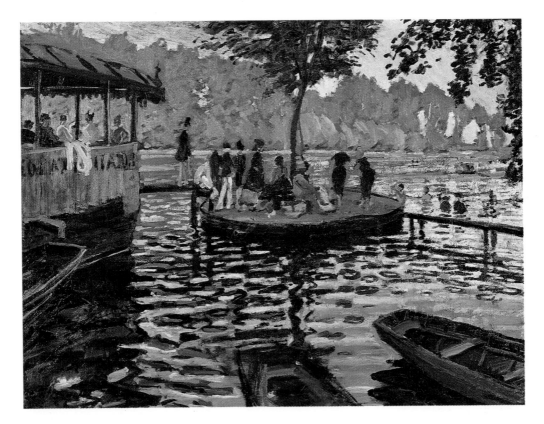

Claude Monet, *La
Grenouillère*, 1869, oil
on canvas, 75 × 100 cm,
The Metropolitan
Museum of Art, Bequest
of Mrs H. O.
Havemeyer, 1929
(29.100.112), the H. O.
Havemeyer Collection.

conveying any social or moral message. This set them apart from
Courbet's brand of Realism, which by the 1860s was more heavily
charged with references to ethical values and contemporary social
conditions.

COLOUR, ATMOSPHERE AND BRUSHWORK At the outset, the
Impressionists' basic concern was the nature of the constantly
changing effects of light on the surfaces of objects in nature and
how to translate those perceptions into painting. This led them to
the analysis of local colour, that is the colour of the object in
nature, bathed in ever changing light. Although their observation
that local colour is made up of more than one colour was not new,
it was their overriding concern with this that led them to develop
their distinctive style of broken brushwork and juxtaposition of
pure colours. Theories of colour harmony, chiefly those of Eugène
Chevreul (first published in 1839), were becoming more widely
discussed, and they stimulated the Impressionists in their explora-
tions of the nature of visual experiences.

They became engrossed in recording the colour variety of

reflected light and noted numerous phenomena, for example, that a colour reflected off water is different from the same colour reflected off snow. Monet and Renoir explored the reflective surfaces of water together at La Grenouillère in 1868 and 1869 where side by side they painted the same scene. To record the reflections of light off a surface that is itself in constant motion led to their developing brushwork to capture the fleeting shapes as well as the elusive colours that played across the surfaces of water. This brushwork has the properties of a brilliant mosaic made up of many colourful and irregularly shaped dabs. The technique of laying in areas of flat colour was part of academic training (used in the *ébauche*) but in the hands of Monet and Renoir it is used for a new purpose and becomes a formal element of the new style. The practice was not always understood, and some critics were harsh in their comments. Albert Wolff, for example, claimed that in Renoir's *Nude in the Sun*, the artist painted the flesh of the model in the process of decomposition.

Paul Signac wrote how Monet and Pissarro, in studying the effects of reflections off snow, were impressed by J. M. W. Turner's way of painting snow. They discovered that he placed a number of strokes of different colours side by side, and that from a distance they reproduced the desired effect. Delacroix had employed a similar device in his murals in Saint-Sulpice in Paris in 1861.

The Impressionists also noted that shadows, like local colour, are made up of not one but many hues, and that the colours in shadows include complementaries of the colour of the object casting the shadow. (On how to paint shadows, Renoir advised young artists to look to Titian and Rubens.) For example, because yellow's complementary is violet (a mixture of the other two primaries, red and blue), the shadow cast by a yellow object will be tinged with violet. This optical phenomenon (which underscores the subjective nature of perception) can be demonstrated by holding up a yellow pencil against a dark (preferably black) background and staring at the pencil until the intensity of the yellow begins to fade. If, at that moment, the gaze is transferred to a piece of blank white paper, the image of the pencil (called an 'after image' because it lingers in the perception of the spectator

after the gaze has been removed from the object) will appear as violet, yellow's complementary, against the white background.

The Impressionists, then, subjected to radical investigation the portrayal of local colour, shadow, and the reflective properties of light off different kinds of surfaces in nature. They explored the effects of light striking the eye, the character of the surroundings, and the atmospheric conditions prevailing at the moment of perception. As colour depends on the organ of perception, and the eye is personal to each individual artist, the importance of colour emphasises the subjective nature of their art. Furthermore, that subjective aspect of Impressionism extends to the spectator as well. When broken brush strokes of pure colour are placed side by side, it is the spectator who unites the colours as he steps back from the painting to achieve the final visual experience. This phenomenon is called optical blending, because the conflation of colour takes place in the optical and perceptual mechanism of the viewer.

The Impressionists' fascination with reflected light extended to the changing light at different times of the day and at different seasons of the year. Although they were not the first to observe these phenomena, the Impressionists' interpretations were distinct from those of the artists of the past. The changing nature of atmosphere and light had been explored by any number of the great masters of landscape, even though their motivations may have differed from those of this nineteenth-century group of painters. John Constable's cloud studies are legendary; Claude Lorraine's views in the seventeenth century of the same scenes at different times of day under different lighting conditions are well known; the popular Italian view painters of the eighteenth century, especially Canaletto and Guardi, some of whose works were painted *en plein air* (departing from the tradition of working from sketches) are important predecessors, as are some of the compositions of the German Romantic painter Caspar David Friedrich, in which he paints the same figure group in the identical setting at different times of the day and under different atmospheric conditions. And, at the end of the eighteenth century, Pierre Henri Valenciennes had painted views of Rome in the evening and morning, the same place at different times of day.

For Monet, who is the best known of the group for doing many paintings of the same subject, there were more immediate influences. One of his teachers, Jongkind, for example, in 1863 and 1864, had painted two views of the apse of Notre-Dame in Paris from the same place, one on a winter morning, the other at sunset. In 1865, the year after Jongkind's second painting of Notre-Dame, Monet followed his master's model: two views of a *Road Near Honfleur* (both lost; reproductions extant) in different atmosphere. Monet was to carry this investigation of the changing quality of the reflective properties of light off surfaces at different times and under different atmospheric conditions much further than his teacher, and he subjected the idea of a series to a much more rigorous programme of painting than had been done by any artist heretofore. The series of paintings of hay stacks and those of Rouen Cathedral, for example, demonstrate the complexity and richness of his search.

PHOTOGRAPHY'S INFLUENCES Another influence was that of photography. Monet's *Boulevard des Capucines* of 1873 (one version was included in the first Impressionist exhibition) is an example that illustrates this influence. Louis Leroy scornfully described the dark daubs of paint in the picture as appearing like 'tongue lickings'. Monet's rendering of the figures is indebted to the experiments in photographing large groups of people at a distance. Before the development of high speed shutters, a photograph was the result of a long time exposure. If the subject moved, it was recorded in a blurred fashion. When a view of a boulevard was photographed with its crowd of people in constant motion, the figures of the strollers were necessarily blurred – like 'tongue lickings'. Ironically, the painting that evoked this criticism shows the view of the Boulevard from the photographer Nadar's studio where the Impressionists held their first exhibition.

Interestingly, William Henry Fox Talbot's invention of photography in 1839 (Daguerre's process was announced at about the same time) was directly inspired by his own landscape sketching. His invention, in turn, had widespread influence on painters. Most of the avant-garde artists were affected by photography in one way or another. Courbet used photographs of nude models for his

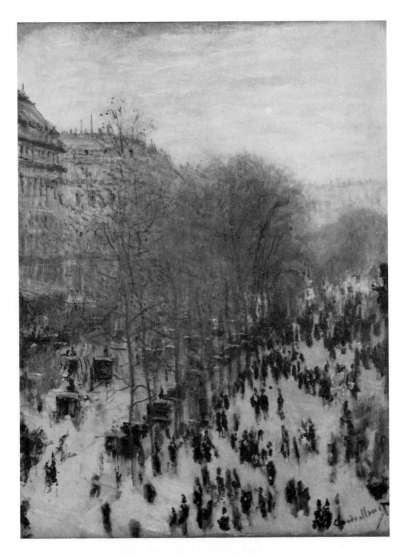

Claude Monet,
Boulevard des Capucines,
1873, oil on canvas,
80 × 60 cm, The Nelson-
Atkins Museum of Art,
Kansas City, Missouri
(Nelson Fund).

paintings of bathers. Some writers have seen the nineteenth-century photographic studio backdrop as influencing some of Manet's backgrounds (*Déjeuner sur l'Herbe*, for example, p. 75). Certain formal properties of framing, space, line and tonal variations appealed to the artists of the avant-garde, in general, and to Degas, in particular. In his race track scenes, the view he shows often portrays figures which are cropped impersonally as the lens of a camera would mechanically select what fits within its rigidly defined frame. This framing creates a pictorial space that is read as part of the spectator's own space as well as part of a larger whole. Furthermore, figures are portrayed in candid, unconventional postures and gestures, as if they had been frozen in mid-act.

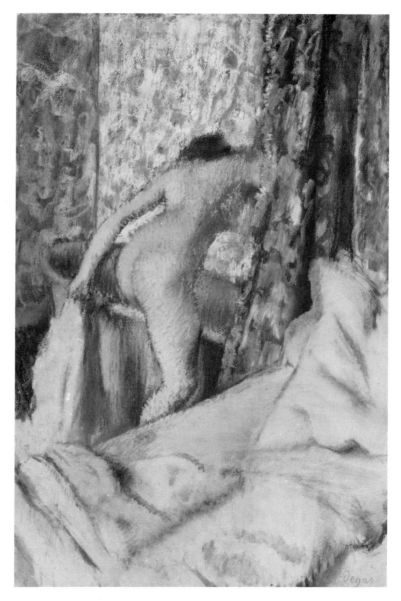

Edgar Degas, *The Morning Bath*, *c*. 1883, pastel on paper, 70.5 × 43 cm, The Art Institute of Chicago.

The sense of catching a glimpse of a scene, place, or event comes over strongly in many of Degas' paintings (*At the Races*, for example); combined with a view of the subject as if seen through a keyhole (*The Morning Bath*, for example) the sense of presence and immediacy is intensified.

5 From Realists to Post-Impressionists

Another strand in the influences that established modern art was an interest in the Italian 'primitives'. These so-called 'primitives' included the fourteenth- and fifteenth-century painters such as Giotto, Masaccio, Fra Angelico, Piero della Francesca and Uccello, who were also called 'Early Christian' painters because of their religious subject matter.

This interest became widespread in the nineteenth century among collectors, artists, scholars and writers. For example, in England, Prince Albert was building a significant collection of Italian primitives and Flemish fifteenth-century paintings. Members of the expatriate artist community in Florence, like the poets Robert Browning, Elizabeth Barrett Browning and Walter Savage Landor, sought them out in the small shops and dealers' galleries in the Tuscan towns and hills. The influential writer on art and architecture, John Ruskin, wrote an enthusiastic account of Italian painters of the *Quattrocento* (the fifteenth century) in his second volume of *Modern Painters* (1846); and numerous other publications appeared at this time that dealt with the history of the early Italian painters and the techniques they employed.

THE NAZARENES

Intrigued by these painters and their techniques, a small contingent of German painters, who were to influence English art and artists, dedicated themselves early in the century to reviving both German medieval religious painting and Italian painting of the Quattrocento. Their Italian models ranged from Fra Angelico and Masaccio to Perugino and Raphael and their principal German model was Dürer. Inspired by the spiritual writings of Wilhelm Heinrich Wackenroder, they organised as the Guild of Saint Luke in 1809, and their ascetic mode of life in an abandoned monastery

in Rome earned them the name 'Nazarenes'. One of their most influential members, Peter Cornelius, served as a consultant in 1841 on the fresco decorations for Sir Charles Barry's new Palace of Westminster in London, and two British painters who were to influence a new wave of painters in England, Ford Madox Brown and William Dyce, studied the Nazarenes' work in Rome.

These influences on Ford Madox Brown's own painting produced a bright palette, meticulous rendering of detail, and more naturalistic colour (*Chaucer at the Court of King Edward III*, for example) qualities that were to affect the young painters in England at mid-century. It is noteworthy that Dyce observed from his study of the Quattrocento painters that their accurate portrayal of light and atmosphere could only have been achieved through a direct study of nature in the open air, a phenomenon that was also to affect the new painters. And, too, he observed that the Quattrocento painters' shadows contained components of the colour of the objects that cast the shadows (see p. 88), a fact the Pre-Raphaelites (see below) and the French Impressionists would observe anew and explore more fully in the nineteenth century.

THE PRE-RAPHAELITES

In this atmosphere of increased interest in early Italian and German painting, John Ruskin's call for truth to nature in art in Volume I of *Modern Painters*, and his admonition to young artists to carry this message, inspired a small group of painters in their late teens and early twenties to emulate the bright colours and close attention to naturalistic detail that characterised the work of the primitives. They were dissatisfied with the sixteenth- and seventeenth-century Renaissance and post-Renaissance influences that dominated the art of the Academy. Each painting was composed according to the same principles of light and shade, each one shone with the same luminosity, the product of a system that, they felt, was stifling to individuality.

Taking as their models the painters before Raphael, this group made up of Dante Gabriel Rossetti, William Holman Hunt, John Everett Millais, William Michael Rossetti, Frederick Stephens,

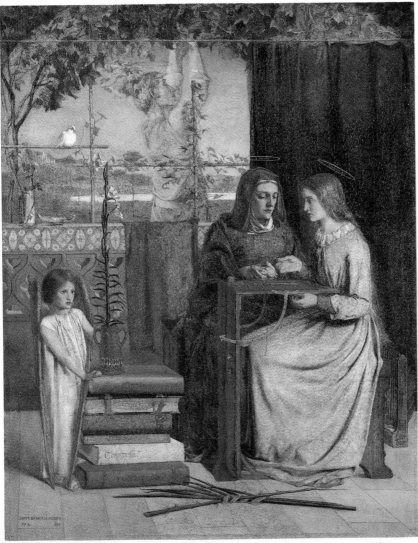

Dante Gabriel Rossetti,
*The Girlhood of Mary
Virgin*, 1848–9, oil on
canvas, 83 × 65 cm, Tate
Gallery, London.

James Collinson and Thomas Woolner organised itself in 1848, as the Pre-Raphaelite Brotherhood. The first picture they exhibited with the identifying initials 'PRB', in March 1849, was Dante Gabriel Rossetti's *The Girlhood of Mary Virgin*.

The following spring, the meaning of the mysterious letters was made public, and brought forth severe criticism of the group for rejecting the hallowed Renaissance tradition. However, John Ruskin came to their defence in *Pre-Raphaelitism*, a pamphlet published in 1851, for being true to nature in their art which is what he had admonished young painters to be in the first volume of his *Modern Painters*. Although this defence and testimonial

95

assured their general acceptance, they did not remain a group for long; each went his own way, but the style they had initiated had far-reaching effects on painting, the decorative arts, book illumination and industrial design of the second half of the nineteenth century.

Drawing its themes from such sources as the Scriptures, English poetry, and Arthurian legends (themes often made to carry a social message), the style is characterised by bright colour, meticulous rendering of detail and accurate portrayal of natural light. For example, Hunt's *Hireling Shepherd* exhibited in 1852 was partly inspired by one of Edgar's songs in Shakespeare's *King Lear*. A shepherd is more interested in the affections of his comely companion than in caring for his sheep. Consequently, the lamb on the shepherdess' lap is being poisoned by green apples and others are doomed by eating the wheat.

Hunt's shepherd, symbolising negligent pastors in mid-nineteenth-century England, is part of a moralising body of painting and writing popular at the time. Ruskin and Dyce, for example, had both written pamphlets with shepherd themes critical of churchmen and ecclesiastical organisations that neglected their pastoral commitments.

Hunt painted the landscape in the open air at the site, a place near the village of Ewell, between Kingston-upon-Thames and Epsom in Surrey, over a period of six months, and he tried to render each form with scientific accuracy and absolute clarity, a hallmark of early Pre-Raphaelite painting. The painting was hailed in his own time as the first modern exploration of coloured shadows. Unlike the French Impressionists later, Hunt was not interested in portraying the changing effects of atmosphere and light but the 'true' colours and shapes of nature in bright sunlight. He achieved his brilliant Mantegna-like colours in *Hireling Shepherd* partly through a technique of working on a moist white ground. The earlier English masters, Reynolds, Gainsborough and Lawrence, had employed white in preliminary modelling, but that was tempera or resin-oil, a fast drying medium. The Pre-Raphaelites' remarkable achievement in rendering detail accurately was acknowledged when they exhibited at the Salon, but the French felt that the overall compositions were not very natural. (They

also did not think that many would follow their example, because the technique took too much time.)

THE LATER WORK Much of the later Pre-Raphaelite painting was less concerned with the appearance of nature than with the introspective portrayal of an inner world of moods. The crisp linear style of gem-like colour was replaced by soft edges, indeterminate shapes and atmospheric tones. Rossetti's paintings of his wife Elizabeth Siddal as Dante's Beatrice is an example. Lizzy Siddal was a favourite model for the Pre-Raphaelites in the early 1850s, when they discovered her in a milliner's shop in Cranbourn Street where she worked. In 1852, she became Rossetti's mistress, and they married in 1860. He taught her to draw and paint and encouraged her gift for writing verse. However, their life became progressively troubled by Rossetti's infidelities, her loss of a child at birth and their dependence on drugs and alcohol. In 1862, Lizzy died from an overdose of laudanum.

Beata Beatrix is not so much a funerary memorial as a monument to their life with each other as a modern-day Dante and Beatrice, a parallel Rossetti, the son of an Italian political refugee, had long cherished. The figures in the background, Dante and a personification of love (or perhaps ghosts of Dante and Beatrice) against a hazy portrayal of Florence, look at each other, symbolic of the bond between both couples. A haloed bird drops a poppy into Lizzy's lap, the flower whence comes the drug that killed her. Lizzy's rapt ecstasy unites an erotic and spiritual mood, akin to Bernini's *St Teresa*, which is both of this world and eternity; the painting rejecting death, retains the loved one in a tangible image.

Much of Rossetti's inspiration was drawn from William Blake, one of whose notebooks he had purchased before painting any pictures. Rossetti's preoccupation with the world of the spirit has often been traced to Blake, and he had a special fondness for the poet's *The Songs of Innocence*. Rossetti introduced the other members of the Brotherhood to Blake, whose sinuous line, convulsive swirls, attenuations and androgynous figures contributed to late nineteenth-century taste, not only through Rossetti, but his followers such as Edward Burne-Jones, who

97

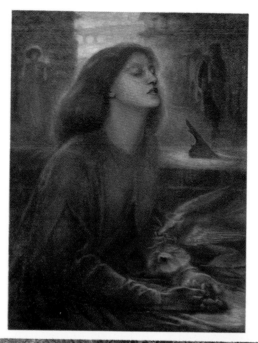

left
Dante Gabriel Rossetti,
Beata Beatrix, *c.* 1863,
oil on canvas,
86.4 × 66 cm, Tate
Gallery, London.

right
John Everett Millais,
Ophelia, 1851–2, oil on
canvas, 76 × 112 cm,
Tate Gallery, London.

below
William Holman Hunt,
Hireling Shepherd, 1851,
oil on canvas,
76.5 × 109.5 cm, City of
Manchester Art
Galleries.

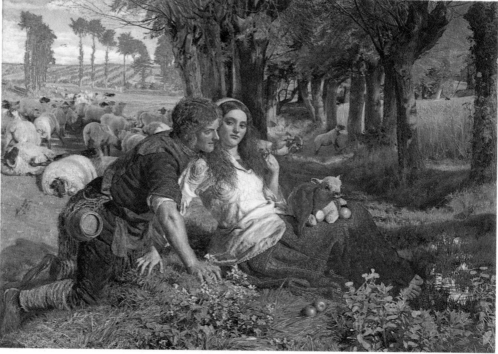

studied with Rossetti and has been called a second-generation Pre-Raphaelite.

In the mature work of Burne-Jones, who had studied for the

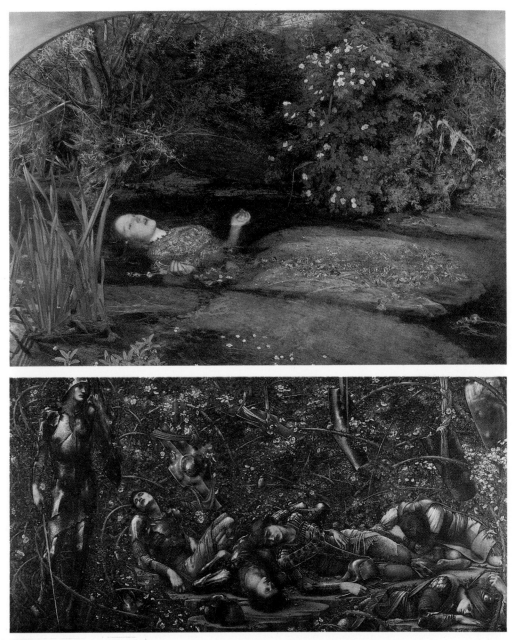

ministry at Oxford before turning to painting, the shift to introspective attitudes and moods, with less attention to observed nature, became full blown, and his compositions conform more closely to principles of decorative design. Burne-Jones' interest in treating the pictorial surface like a coherent design may be traced partly to his attraction to such ritual art as manuscript illumina-

99

tion and medieval tapestries. To illustrate this shift, Burne-Jones' landscapes from the *Briar Wood* series have been contrasted with the landscapes of Millais, such as in *Ophelia*. The enormously varied collection of flowers accurately and meticulously rendered in the earlier painting, *Ophelia*, serves to give the scene actuality and immediacy, drawing the spectator into the verdured space to behold the tragic and lifeless body of Ophelia. Burne-Jones, however, depicts one kind of plant, endlessly repeated and interlaced to form a carefully developed two-dimensional surface design, an overall pattern as in decorative wallpapers. The languorous, androgynous figures are arranged frieze-like but fixed by the trelliswork of interwoven tendrils in a shallow space. Burne-Jones' elongated and introspective figures are inspired by the fantasy world of Botticelli, and his rich patterns were a formative influence on ecclesiastical as well as secular design through the Arts and Crafts Movement to which he was a major contributor.

ARTS AND CRAFTS MOVEMENT

The British government had encouraged the collaboration of the arts and crafts industry since 1754 with the establishment of the Society of Arts, revived under Prince Albert in 1847, and in 1835 by setting up the government schools of design to raise the standards of design in manufacturing. Ruskin and members of the Pre-Raphaelite Brotherhood taught in the government schools and instilled their ideas of truth to nature and art's capacity for doing good into their students, who were goldsmiths, jewellers, furniture makers, lithographers and draughtsmen of the day.

By the first quarter of the nineteenth century, prefabrication and mass production had virtually decimated the traditional craft guilds, in which work had been done by hand. The efforts to unite art and manufacture theoretically provided jobs for the craftsmen and elevated the aesthetic content of manufactured goods, but in fact craftsmen were slow to adjust to the transition from singly produced items; consequently, foreign designers, largely French, were employed. However, in the decade following the Great Exhibition of 1851, Sir Henry Cole, successful designer, writer,

editor and civil servant, opened the South Kensington Museum and connected it with the government schools of design. While his aim was primarily to refine public taste through education, he succeeded in substantially increasing the number of English designers in industry, a boon for English labour.

As the arts and industry became increasingly compatible, forceful and influential voices were raised to regenerate the craft tradition of the Middle Ages. John Ruskin's *Stones of Venice* (first published in 1851) contained a chapter 'On the Nature of Gothic', in which he analysed medieval art as the 'expression of man's pleasure in labour'. For Ruskin, medieval craftsmanship expressed the happy and homogeneous spirit of the society that produced it, and his impassioned plea on its behalf fired the youthful missionary spirit of William Morris, who became a major force in the revival of the craft tradition to improve both design and society, which became known as the Arts and Crafts Movement. The movement got its name from the Arts and Crafts Exhibition Society founded in London in 1888, and its name was coined by one of its members, T. Cobden Sanderson.

Morris studied for the ministry at Oxford and was a friend there of Burne-Jones. He subsequently joined the young architectural firm of George Edmund Street, whose early work was influenced by Ruskin. Like Burne-Jones, he turned to painting and studied with Rossetti. In 1859, he married Jane Burden who was known as a 'stunner' (Victorian slang for a beautiful girl), whose face became a prevailing type in Pre-Raphaelite paintings, especially those of Rossetti and Burne-Jones. Morris' friend (and fellow assistant at Street's) Philip Webb designed a house for them, called the Red House, at Bexley, which marked a turning point in English house design towards a simpler style. The house was built of red brick with high gables, Gothic arched windows and doorways, bull's-eye windows, steeply pitched roof and a square hedged garden. To furnish the house appropriately (elaborate Victorian pieces clashed with the simplicity of the house), original pieces were designed for it, which led Morris to found his own company in 1861, whose production was organised along the lines of the medieval workshops.

Morris rejected the industrialisation of design and insisted that

On the bed canopy frieze (embroidered text):
"he winds on the wold and the night is a-cold, and Thames runs chill 'twixt mead & hill, but kind & dear is the old house here rest then & rest, and think of the best 'twixt summer and spring, when all birds sing in the town of the tree, and ye in me and scarce can leave off the long day and my heart is warm 'gainst winter's harm"

above
Morris's bedroom at Kelmscott Manor; the Elizabethan four-poster bed has embroideries by Jane and May Morris.

far right
An oak armchair with rush seat; probably designed in Norman Shaw's office in 1876 and sold by Morris & Co. Victoria and Albert Museum, London.

right
Silver vase with marble stand, designed and made by Omar Ramsden and Alwyn Carr, London hallmark for 1900–1. Victoria and Albert Museum, London.

Peacock pendant, silver set with pearls, 1900, designed by C. R. Ashbee and executed by the Guild and School of Handicrafts. Victoria and Albert Museum, London.

art should be created by man for man. While he failed to offer a solution to the economic dilemma that handmade goods are more expensive and therefore limited to an elite and not the wide audience he wished to reach, he has been credited with laying the foundations for the twentieth-century practice in which artists design for industry and mass-produced goods, thereby creating enlightened design for the general public.

Morris's firm designed everything for interiors and daily use including wallpaper, stained glass, carpets, textiles, tapestries and furniture; their patterns included designs by Morris himself, Rossetti and Burne-Jones, and became enormously popular, setting styles and forming public taste. Although some of the firm's interior creations were exhibited as early as 1862 in the International Exhibition (scheduled for 1861, a decade after the Great Exhibition, but postponed because of the Italian War), Morris's full impact on English design was not felt until the 1870s.

Morris's designs rejected the deep space of Victorian design in favour of flat overall patterns of flowers and birds recalling the interlace of Celtic relief and medieval manuscript illumination, and woven patterns. Among the motifs that Morris made popular were the daisy, honeysuckle, tulip, violet and columbine, as well as various birds, especially the peacock, which alternated with sinuous dragon forms. He was indebted to *The Grammar of Ornament* (1856) by architect and designer Owen Jones, a rich source of designs from many cultures and many media from tapestry to mosaics emphasising flat patterns and geometric forms. These principles were carried into the field of book design when Morris established his Kelmscott Press in 1890, which set new standards for book design and printing that affected the industry internationally.

Morris's efforts for social and aesthetic improvement through the union of art and craft was brought to public notice by his designs and workshops, by his poetry, and most notably, from 1877 until his death in 1896, by his highly influential lectures. Through his commitment to social reform, he became one of the founders of organised socialism in England.

104

J. A. McN. WHISTLER

Morris's re-linking of art to work derived from Ruskin's conviction that the value of a work of art was related to the amount of work invested in it, which was in part behind the critic's attack on James McNeill Whistler's *Nocturne in Black and Gold: The Falling Rocket* exhibited at the opening of the Grosvenor Gallery in 1877 (a gallery that provided a place for artists outside the Royal Academy to exhibit). The subject of the painting is the fireworks at Cremorne Gardens, a popular park in Chelsea, and the unstructured execution of the event Ruskin found to be slovenly and an affront to acceptable standards of art. He wrote a severely harsh criticism of the painting in *Fors Clavigera*, a series of letters aimed at the craftsmen of Britain to encourage them to improve the level of design in industry. 'I have seen, and heard, much of Cockney impudence before now; but never expected to hear a coxcomb ask two hundred guineas for flinging a pot of paint in the public's face.' At that time, Ruskin was the prestigious Slade Professor of Fine Art at Oxford and the most influential art critic in England. Therefore Whistler felt he could not leave the attack unchallenged. So he sued Ruskin for libel and won a symbolic victory of one farthing. The costs of the trial, however, left the painter bankrupt, and the publicity from it adversely affected his reputation.

While Whistler's victory was financially and psychologically damaging to him, the voluminous recorded testimony of the trial is a valuable record of the issues. His testimony, for example, clearly distinguished opposing points of view on the relationship between art and work. When Whistler was asked to justify his price for two days' work (the length of time he said it had taken him to paint the *Nocturne*, which was probably not true), he said his price was based on the knowledge of a lifetime.

Whistler was an American by birth (from Lowell, Massachusetts), although at his trial he said he was born in St Petersburg, Russia. He attended West Point, where he studied with Robert Weir (who had studied with Pietro Benvenuti, a Neoclassical painter in Florence), and subsequently worked as a draughtsman for the US Coast Survey in Washington, DC, where he developed his skills as an etcher, before moving to Europe.

left
Page of book illustration from Owen Jones, *Grammar of Ornament*, 1856.

James Abbott McNeill Whistler, American, 1834–1903, *Nocturne in Black and Gold: The Falling Rocket*, 1874, oil on oak panel 60.3 × 46.7 cm, no. 46.309. Gift of Dexter M. Perry Jr, courtesy of The Detroit Institute of Arts.

He lived in Paris from 1855 to 1859 (and again in 1892); then he moved to London, where he remained for the rest of his life, except for trips to South America and Venice. In Paris, he met Henri Fantin-Latour and Degas and worked with Courbet, whose training and influence he later criticised for its lack of discipline. He regretted not having studied with Ingres from whom he would have learned the fundamentals of composition, colour and anatomy – training he lacked. A true 'cosmopolite', neither the English nor the French were able to lay claim to him. The English considered him an Impressionist, and the French identified him with the English school of painters. The often discussed confusion was partly due to the fact that he studied at Gleyre's atelier and

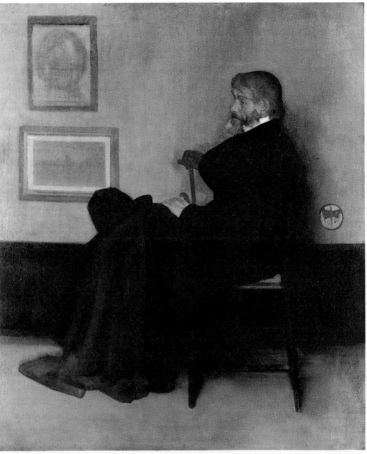

James Whistler,
*Arrangement in Grey and
Black No. 2 – Thomas
Carlyle*, 1872, oil,
171 × 143.5 cm, Glasgow
Art Gallery and
Museum.

that in the early 1870s, he exhibited with Monet, Degas, Pissarro, Renoir, Sisley and Fantin-Latour at the Bond Street Gallery of the French dealer Durand-Ruel, and his style reflected the French influence noted in the resemblance between Whistler's *At the Piano*, portraying the painter's half-sister and her daughter, and Fantin-Latour's *Two Sisters* of the same period.

In the 1860s, Whistler explored the possibilities of colour and innovative composition in which the Japanese print, Chinese design, and the Pre-Raphaelites were influential. In fact Whistler met Rossetti in 1862, and they became neighbours shortly thereafter in Chelsea.

TOWARD A NEW DEFINITION OF PAINTING Dissatisfied with a lack of precision that he perceived in his work and in search of greater control over his medium, Whistler developed a system of composition and colour, in the 1870s, based on close structural

and tonal interrelationships. Among the influences that shaped his new system, the absence of conventional perspective and subtle tonalities of the Japanese print are especially apparent.

For Whistler, a painting was first an arrangement of line, form and colour on canvas or panel coordinated with the frame that surrounds it. He perceived the entire object as the work of art and the interrelationship of all its parts as essential. *Arrangement in Gray and Black No 2*, portrait of the Scottish historian, philosopher and essayist, Thomas Carlyle, embodies Whistler's newly developed systems of line, form and colour on a flat surface. The figure of Carlyle, the objects in the room, the background and the picture frame are all equally important components, as are their colour and their tonal interrelationships. The painting is both representation and pattern, and Whistler strives to keep them in balance. The composition is a vertical rectangle divided by the juncture of floor and wall into two horizontal rectangles, one on top of the other. These vertical and horizontal shapes are repeated in the two pictures hanging on the wall in the upper left hand side of the painting, a device which serves to relate the forms within the picture to each other and to the frame.

The seated figure of Carlyle is depicted in profile, which emphasises his silhouette as two-dimensional design and brings the sitter and the background into balance; the sizes of the pictures on the wall establish the short distance from the sitter to the wall and further stabilise the balance between sitter and background. Carlyle's silhouette is made up of predominantly convex forms, which keep it in front of the wall or, in terms of two-dimensional pattern, make the figure appear to rest on the ground. Carlyle's entire silhouette is contained within the frame, which reinforces the form as figure against ground.

To modulate the distance (or space) between figure and ground, and thereby maintain a close equilibrium between them as pattern, Whistler softens the edges of the dark silhouette with a feathery line (a device he borrowed from Velazquez and Rembrandt) uniting the figure and the ground. To further emphasise the formal relationship between figure and ground, Whistler renders Carlyle's clothing with a minimum of modelling, a technique indebted to Manet's broad flat brushwork (p. 78).

convex *concave*

Concave forms recede or appear to be behind or to pierce the ground.

By using only a few colours and concentrating on the relationship between light and shade, Whistler discovered he could achieve greater coherence than in his earlier works. The light wall and dark figures against it are monochromatic and the modelling of Carlyle's drapery is minimal, maintaining a uniformly flat surface; only Carlyle's face and hands are more finished, three-dimensionally modelled, and contain a variety of colour. In this treatment of the most expressive elements of a portrait, Whistler acknowledged his two-fold purpose here of making a portrait as well as a picture.

In spite of his apparent disdain for hard work, Whistler was a slave to his craft. He often took days to block out the colour masses and tonal nuances of a painting on his palette before he touched brush to canvas or panel. Then once he started, he would rework, rub out, and rework again passage after passage to achieve the effects he desired. Carlyle became so exasperated at Whistler's perfectionism that he discontinued his sittings and, in order to finish the drapery for Carlyle's portrait, Whistler had to get a substitute model. But Whistler believed that the finished work should not reflect the physical effort required. The painting should appear as a beautiful flower requiring 'no reason to explain its presence'.

Although Whistler believed that a painting should stand on its own merits, independently of anecdote, history and drama (l'art pour l'art; art for art's sake), he was equally insistent that nature was its true source. In the famous *Lecture at 10 O'Clock in the Evening* (called the *Ten O'Clock Lecture*), which he delivered in London, Oxford and Cambridge in 1885, and which Stéphane Mallarmé, the symbolist writer and also a friend, translated into French in 1888, he observed that 'nature contains the elements, in colour and form, of all pictures, as the keyboard contains the notes of all music'. This attitude helps to explain his use of musical nomenclature in titles, as well as his subtle harmonies of colour which he felt were analogous to the intervals of musical harmony. He also employed colour combinations unusual for his time (for example, *Nocturne in Blue and Green*, *Harmony in Violet and Yellow*) but which became common in Art Nouveau.

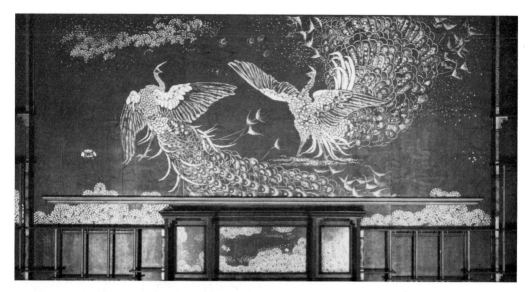

James Whistler, Peacock Room, Leyland's house, now in Freer Gallery of Art, Washington DC.

THE PEACOCK ROOM Whistler was a leading spokesman for the much discussed Aesthetic Movement, from which he tried to separate himself in the *Ten O'Clock Lecture*. Without founders or manifesto, it was not an artists' movement and it cannot be traced to a single group or work. It describes a pervasive aesthetic awareness in contemporary society from the 1870s to which many artists and artisans contributed and it included fine art as well as industrial art. Because of its universality and what was perceived as superficiality, artists like Whistler chose not to be associated with the name. Yet Whistler produced what many think of as the movement's most extraordinary single monument, the Peacock Room in his friend Frederick R. Leyland's home at 49 Prince's Gate, London (now installed in the Freer Gallery in Washington DC). The room was designed by architect Thomas Jeckyll for Leyland's collection of Blue and White china, and Whistler was so taken with Jeckyll's elaborate interior that he wished to enhance it further. Whistler's painting *La Princesse du Pays de la Porcelaine* (exhibited in the Salon of 1865) hung at one end of the room and he saw the room as a kind of extension of his painting. After Leyland agreed to minor modifications in some of the colours, Whistler proceeded to execute a full-scale mural of peacocks, a central motif and symbol of vanity in the Aesthetic Movement which was later adopted by the practitioners of Art Nouveau at the end of the century.

Although Leyland was displeased and a subsequent disagreement over Whistler's fee led to a rupture in their friendship, the

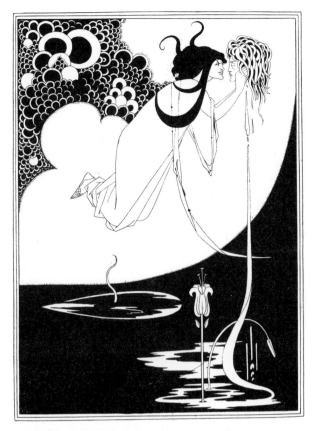

Aubrey Beardsley, illustration from Oscar Wilde, *Salome*, 1894, pen and ink, 17.7 × 12.9 cm.

influence of the room on the art and design of the period was widespread; for example, Aubrey Beardsley's peacock illustrations for Oscar Wilde's *Salome* were inspired by the artist's visit to the room in 1891. The popularity of the peacock motif is well attested. Whistler's friend, the painter Albert Moore, had used it in his designs for a house in Berkeley Square in 1872, Rossetti kept peacocks in his menagerie in Chelsea from the 1860s, Edward William Godwin (who built Whistler's spectacular White House, which the painter had to sell when he went bankrupt) designed peacock wallpaper, and Whistler himself had suggested a peacock decoration for W. C. Alexander's mansion on Campden Hill in 1873.

The idea of the room as a coherent artistic creation in which paintings, decoration and structure are unified became increasingly popular and a hallmark of Art Nouveau at the end of the century. For example, when Whistler exhibited a large number of his etchings at the Fine Art Society in London in 1883, he had the walls of the exhibition rooms all painted white with yellow borders and drapes of yellow velvet on which his insignia, the butterfly

(with which he also signed his paintings), was embroidered. Floor coverings, chairs and vases were also in yellow and the ushers wore yellow and white.

ART NOUVEAU

In the last decade of the century, there came together principal ideas of aestheticism, industrialisation and the Arts and Crafts Movement with pictorial forms from such diverse sources as William Blake, the Pre-Raphaelites, oriental art, celtic art, the decorative arts, and book illumination to produce a distinctive style of decoration that was the first to break successfully with the past. The style encompasses architecture, interior design, and ornament and its hallmark is the sinuous line based on naturalistic plant forms epitomised in *Jugendstil* artist Hermann Obrist's *Whiplash*. The universal application of Art Nouveau's forms to all the arts brought about a synthesis of art, as well as the phenomenon of the universal artist who worked in many media. It spread throughout Europe and the United States and went by different if similar names. In France, it was called both Modern Style (the English name to acknowledge its English origins) and Art Nouveau from the name of the German dealer Siegfried Bing's shop, L'Art Nouveau, opened on 22 December 1895 in Paris. In Germany it was called Jugendstil from its publication *Jugend*, in Italy Stile Floreale or Stile Liberty (referring to Arthur Lasenby Liberty's shop in London), in Catalan Modernista.

The main progenitors of Art Nouveau were the Arts and Crafts Movement and industrial design. Formative influences of the new style can be traced to some of their major figures. Arthur Heygate Mackmurdo's title page for *Wren's City Churches* (1883) is based on one of Owen Jones's (*Grammar of Ornament*, see above) principles that undulating forms should have a single source. By combining Jones's principle with asymmetry and elongated tendril-like curves, Mackmurdo introduced a motif that over the next decade would become the hallmark of Art Nouveau. Mackmurdo, enamoured of Ruskin and Morris, founded the Century Guild in 1882, an association of architects, artists, and

Hermann Obrist, *The Whiplash*, 1895, silk embroidery on wool, 119 × 183 cm, Stadtmuseum, Munich.

designers, for the purpose of extending art in industry. He then launched the Guild's magazine, *The Hobby Horse* in 1884 (published by George Allen who had published the *Fors Clavigera* letters, p. 105), which borrowed forms from the Middle Ages that were to influence Morris' Kelmscott Press.

Christopher Dresser, who taught at Henry Cole's schools of design and studied botany, worked with Jones on his *Grammar of Ornament* and in 1862 published *The Art of Decorative Design*. Understandably partial to plant forms, his designs cover a wide variety of utilitarian objects and materials such as metalware, glass, wallpapers, ceramics and furniture. His aim was to transform natural forms into ornamental ones. His influence was widespread extending to architectural decoration in Europe and the United States.

Walter Crane and Kate Greenaway produced children's books that influenced taste in illustration for generations. Crane was influenced by Blake, Burne-Jones and early manuscript illumination. The score of children's books and stories he illustrated include *Beauty and the Beast*, *The House that Jack Built* and *The Baby's Opera*. He also designed textiles, carpets, tiles, stained glass, pottery and wallpapers.

113

Kate Greenaway,
frontispiece of *Marigold
Garden*, 1885,
26 × 22 cm, Keats
House, Hampstead.

Kate (Catherine) Greenaway's illustrations for such publications as *People's Magazine* and designs for valentines were among her first commercial successes. She was immortalised, however, in her illustrations for children's books and stories, which also had wide circulation internationally. *Under the Window*, for example, was also published in Germany, and her French edition sold more than 100,000 copies. Admired by Ruskin for the world of beauty she created, she was with Crane and Randolph Caldecott the most successful illustrator in her field of her time. Foreign museums began buying the works of these artists at the end of the century, recognising their importance as works of art.

DESIGNER PAR EXCELLENCE In the designs of Aubrey Beardsley, Art Nouveau reached its height of cosmopolitan

Louis Comfort Tiffany, vases, heights 29, 18 and 47.5 cm, Haworth Art Gallery, Accrington.

sophistication. A child prodigy in music and literature as well as gifted in art, Beardsley's extraordinarily productive life was cut short by consumption at the age of twenty-six. He drew from many sources, ranging from Greek vase painting, to Renaissance art, to the Japanese print. Among his contemporaries, he was particularly indebted to Whistler and Burne-Jones.

As a child in Brighton Grammar School, Beardsley copied from Kate Greenaway's illustrations, then studied at the Westminster School of Art. He published illustrations for the first volume of *The Studio*, and he was art editor of *The Yellow Book* (1894–6) and *The Savoy* (named from Mackmurdo's elegant hotel). He illustrated Oscar Wilde's *Salome* and such classics as Pope's *Rape of the Lock* and *The Lysistrata of Aristophanes*. Attracted to erotica, mystery and the world of the unconscious, his work was criticised by some as decadent. Yet his genius in interpreting and enriching a text through a clean, crisp and bounding line carried illustration and design to new heights of expression and refinement.

Beardsley's interest in the unconscious was another part of Art Nouveau that was intensified at the end of the century and is expressed for example in George Minne's fountain in the

Folkwang Museum in Hagen. The theme of narcissism is straightforwardly stated in the kneeling youth repeated five times around the basin embracing himself and gazing at his reflection.

SULLIVAN AND TIFFANY American architect Louis Sullivan used the Art Nouveau style primarily to enhance the surfaces of his buildings. The structural members of metal, covered with decorative cladding of terracotta, brick or stone, remain visible. However, the manner in which Sullivan designed thin mullions to rise into and interweave with the ornament at the attic storey in such buildings as the Condict Building in New York invites a comparison with practitioners of Art Nouveau. Sullivan's bull's-eye windows (for example, in the Guaranty Building and the Wainwright Building) owe a debt to the progenitors of Art Nouveau, in the Arts and Crafts Movement, for example Philip Webb's Red House for William Morris.

The leading exponent of Art Nouveau in the United States was Louis Comfort Tiffany, who turned from painting to interior decoration, after travelling to Paris for further study. Under the influence of contemporary Art Nouveau as well as Moorish and Japanese art, he incorporated forms and patterns into the development of a new method of producing iridescent and opalescent glass work that he patented under the name of Favrile (from 'faber', the Latin for artisan), in this way making the point that he regarded each piece as a unique work of art.

Beginning with stained glass design, he extended his production to include lamps, vases and all forms of glass, and established a highly successful industry. His work is characterised by smoothly flowing forms of both transparent and opaque glass with rich colours produced by various metallic vapours, and familiar Art Nouveau motifs such as the peacock feather were often suggested by the inventive manipulation of the molten glass.

CHARLES RENNIE MACKINTOSH With the work of Charles Rennie Mackintosh and his followers of the Glasgow School, Art Nouveau design is brought into more rectilinear and almost symmetrical format, with less emphasis on figurative design, anticipating the art and architecture of the twentieth century. This

Charles Rennie Mackintosh, doors to the Room de Luxe, the Willow Tea Rooms, 1903, Hunterian Art Gallery, University of Glasgow, Mackintosh collection.

is particularly well exemplified in the double doors for one of Miss Cranston's fashionable Tea-Rooms in Glasgow. Of painted wood, metal and coloured glass, the general symmetry is broken by minor changes in a shaped mirror image from one panel to the other.

Mackintosh studied at the Glasgow School of Art, and with the Macdonald-sisters, Margaret (whom he married) and Frances, he designed graphic and metal work in the Art Nouveau style.

SYMBOLISM AND FANTASY

Frustrated by the growing materialism of the age, an increasing number of artists sought to give meaning to life through an inward search for universal and personal truth. If their explorations of dreams and their focus on the human emotions did not always produce the hoped for solutions, they did produce an art of subjects and symbols that expressed the preoccupation of the age

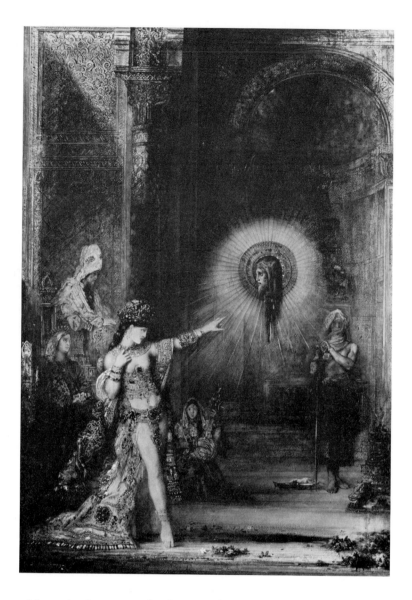

Gustave Moreau, *The Apparition*, 1876, watercolour, 105 × 72 cm, Louvre, Paris.

with such themes as death, sex, demonism and spirituality. In Gustave Moreau's *Apparition*, for example, Salome gazing on the severed head of St John the Baptist is the incarnation of lust and an image of the *femme fatale*, and Odilon Redon's fascination with the supernatural and dream imagery is embodied in *Death; My Irony Surpasses all Others*.

A rise in religious mysticism took on elaborate trappings that affected the visual arts with the revival of the Rosicrucian Order in France (an esoteric cult claiming origins in ancient Egypt, which was resurrected in modern times through the writings of Johan

Leonardo da Vinci, *St John the Baptist*, Louvre, Paris.

Valentin Andrea). Joséphin Péladan, art critic and novelist, who claimed to be a descendant of the Magi and dressed in ancient Assyrian costume, was its leader in the nineteenth century. Central to his thought was the unified image of male and female, the subject of his novel *L'Androgyne* (1891), and which he saw embodied in Leonardo's androgynous portrayal of *St John the Baptist*. Through the attraction and subsequent union of male and female, the human form is made whole. The role of art is unique, because art alone, not nature, creates the androgyne and liberates man from sexually seeking his completion.

Les Salons de la Rose + Croix opened on 10 March 1892 at the Galerie Durand-Ruel, preceded by a Solemn Mass in the Church of Saint Germain L'Auxerrois with selections from Wagner's *Parsifal*. Almost seventy artists exhibited more than 200 works, and it was hailed by some critics as the great show of the year. Although they were not members of the group, inspiration came from Redon, Moreau and Burne-Jones. Among the artists who made up the first exhibition was Emile Bernard, who provided a link with a group of painters at Pont-Aven in Brittany led by Paul Gauguin.

POST IMPRESSIONISM

PAUL GAUGUIN Bernard first met Gauguin (1848–1903) at Pont-Aven in Brittany in 1886, and two years later they began working together. Bernard's fascination with medieval art had led him to develop with his friend Louis Anquetin a flat and decorative style of clearly defined compartments of colour as in medieval stained glass or cloisonné enamels (cloisons are the compartments or cells that hold ceramic colour pastes) which became known as cloisonnisme.

They developed a style characterised by flat patterns of brilliant colour often outlined in dark tones or black, which combined Gauguin's interest in Japanese and primitive art and the applied arts (for example his little discussed ceramics with Breton designs) with cloisonnisme. The expression of ideas, moods and emotions in their work aligned them with the literary Symbolists, who sought to 'clothe the idea in sensitive form', as their spokesman poet Jean Moréas had declared in the Symbolist Manifesto published in *Le Figaro* in 1886. These notions are embodied in Gauguin's *Jacob Wrestling with the Angel*. Jacob is a symbolic figure of alienation and regeneration. Because he deceived his father to steal his brother Esau's birthright and his father Isaac's last blessing, he was condemned to a life of separation from his mother, Rebekah. But through a series of chastening tribulations and miraculous revelations, Jacob was reconciled with God and family. Gauguin portrays the scene when Jacob wrestles with a messenger of God, who reveals to Jacob his new name, Israel, ancestor of the Hebrew people, and he places the event in the native Breton landscape indicated by a cow and an apple tree. The painting unites this world and that of the Bible through an apparition which a group of Breton peasants experience when they emerge from their church on a Sunday morning.

To convey the sense of apparition, Gauguin portrays the groups out of scale: the cow is too small and the Breton peasants in their white bonnets are too large. The surface of the composition is divided diagonally by the apple tree, as in a Japanese print; and the absence of shadow and the flat, clearly defined colourful forms illustrate his new ideas of structure. Gauguin tried to install the

painting in the medieval church at Nizon nearby, hoping it would be compatible with the old building's character, but the pastor explained that his parishioners would not understand the picture and respectfully rejected Gauguin's offer.

In bringing together the expressive qualities of both line and colour to exaggerate or simplify their depiction of observed reality, Gauguin and his followers achieved a long sought after synthesis, well illustrated in their Pont-Aven paintings exhibited at the Café Volpini in Paris. Gauguin, who considered himself an Impressionist, combined his two allegiances in the title of the exhibition, Groupe Impressionniste et Synthétiste (1889).

The ideas developed by Gauguin, who was seen as the prophet of a new art, and his followers at Pont-Aven were continued by the Nabi group (a Hebrew word for prophet) which included Maurice Denis who articulated a definition of modern painting, that before a painting is a horse, a nude or anecdote of any kind, it is essentially a flat surface covered with colours according to some design.

Gauguin, together with Cézanne, Van Gogh and Seurat, who were identified with Impressionism, made something of Impressionism that had immediate effects at the time and influenced twentieth-century art as well, and they are the principal figures in what is called Post-Impressionism. The term 'Post-Impressionism', although an imprecise one, has grown to cover the period from the last Impressionist Exhibition in 1886 to the birth of Cubism in the first decade of this century. The name coined by Roger Fry was used for his exhibition of 1910–11 'Manet and the Post-Impressionists'.

Gauguin infused his Impressionist style with intense colour, gave it a new structure and united it with contemporary symbolism. His works at Pont-Aven were among his most successful and the most influential for the development of art. In the 1890s he lived in Tahiti, the period of his life that has become the best known, and his works during that time focused more closely on the simple life of the people unsullied by western civilisation. Van Gogh, also dissatisfied with the limitations of Impressionism sought to put feeling or expression back into painting, for which he is also called an Expressionist. Cézanne

Paul Gauguin, *Jacob Wrestling with the Angel*, called also *The Vision After the Sermon*, 1888, oil on canvas, 73 × 93 cm, National Gallery of Scotland, Edinburgh. Gauguin illustrates what he terms the 'superstitious simplicity' of these people who collectively watch an event that takes place only in their imagination.

evoked and Seurat imposed a structural dimension to Impressionism.

PAUL CEZANNE Paul Cézanne (1839–1906) wanted 'to make of Impressionism something solid and durable, like the art of the museums'. This indicates his interest in the underlying permanent structure of nature and points the way to his mature style, which retains the underlying discipline of the finest achievements of classical antiquity. Inspired in his early years by Delacroix, Courbet and Manet, Cézanne imitated them in his early works, often not successfully.

Cézanne was uncomfortable with the Impressionist's emphasis on capturing the constantly changing effects of light and colour in nature; he needed structure and the time in which to put paint to canvas. He slowly and methodically developed a style based upon the meticulous observation of nature and in which his preoccupation was with the use of paint itself, the application of colour, and with the very stroke of the brush itself. Cézanne sought to achieve

Paul Cézanne, *Still Life with a Fruit Dish, Glass and Apples*, 1877–9, oil on canvas, 46 × 55 cm, collection René Lecomte, Paris.

well-ordered and harmonious compositions by accurately replicating formal and tonal inter-relationships he saw in nature, and he applied this principle to landscape, still-life, and portraiture alike.

In *Still-Life with a Fruit-Dish, a Glass and Apples*, each piece of fruit is viewed separately and each from a different vantage point, which means that the sizes of the individual pieces are not necessarily consistent with each other and with the setting. Equally different views of individual objects are combined to make a stable composition. For example, the top of the fruit dish is portrayed from one point of view and its base from another, so also with the drinking glass. The bowl of the fruit dish is pulled to the left of its base, yet the bowl relates comfortably to the cluster of leaves at the upper left corner, which are reflected by another group at the upper right corner. A strong diagonal is established from the leaves at the upper left through the bowl of the dish, the cluster of fruit in the centre, and the knife and flap of drapery at the lower right. A slightly less pronounced diagonal (because of darker, therefore receding, tones) is established from the leaves at the upper right through the glass, the central group of fruit, and table edge at lower left. The intersection of these two diagonals at the centre of the composition creates a stable armature on which Cézanne builds his picture.

Each of the objects is constructed of carefully applied brush

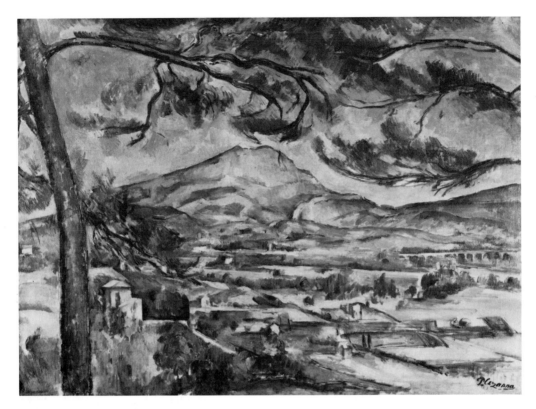

Paul Cézanne, *La Montagne Sainte-Victoire*, 1886–8, oil on canvas, 66 × 90 cm, Courtauld Institute Galleries, London.

strokes and each brush stroke performs a specific task in depicting reflected light and receding planes. These planes in turn depict basic shapes in the underlying geometric structure of nature such as cones and spheres. Each object is related to the one(s) next to it and therefore may be said to create its own space. Cézanne preferred to think in terms of distances between objects rather than space.

Cézanne achieved some of his most successful parallels with nature in his paintings of the mountain near Aix which he painted countless times. In *La Montagne Sainte-Victoire*, each undulating form in nature is treated like each piece of fruit in his still-life. In the landscape painting, however, nature's almost infinite tonal nuances are carefully noted with each brush stroke's relationship to the next adjacent one. The overall effect is one of a limited colour range but a vast tonal range. Thus, what Cézanne achieves is an overall representation of nature's subtle harmonies. It is noteworthy that shadow takes on new interest for him later in his life, and that his paintings of Mont Sainte-Victoire, dominated by warm earth tones earlier, ultimately take on a rich blue colour.

GEORGES SEURAT Georges Seurat (1859–91) produced highly organised and meticulously executed paintings that have little in common with the structural ideas of Cézanne. A product of the Ecole des Beaux-Arts but responsive to the Impressionists' handling of light and colour, ideas of Delacroix and contemporary colour theories, Seurat developed a systematic approach to colour and line of engineering-like precision. The aesthetic theories of Charles Henry in *Introduction à une Esthétique Scientifique* gave Seurat a scientific basis for relating moods and emotions to line and colour; for example, feelings of calm are conveyed through a balance between light and dark values, warm and cold colours, and horizontal lines. From these sources, he developed his theory of Divisionism (also called Pointillism), a term which conveys his version of optical mixtures (already used by the Impressionists) as well as the nature of his brushstroke. Dots of primary colours such as blue and yellow, placed side by side, will produce a brighter secondary colour, in this case green, in the eye of the beholder than would be produced by mixing the pigments on the palette. All the dots are of a uniform size, which is determined by the size of the painting and the distance from which it is to be viewed in order for the proper optical mixture to be achieved. The dots are continued onto the frame to incorporate it into the composition. His style became known as Neo-Impressionism.

Sunday Afternoon on the Island of Grande Jatte, illustrates the distinctive brush stroke that Seurat developed and the highly stable construction he achieved through, in addition to the myriad dots, rigid postures in profile and front view, strong vertical and horizontal elements, and the arrangement of figure groups in recessive planes. The use of multiple perspective (there is no one single point from which the viewer is to see the picture) contributes to the flat and frozen-like quality of the composition and plays down the figure of the child dressed in white at the centre of the composition. White is a union of the three primary colours and the composite colours, therefore this little figure becomes a point of resolution, its central position reinforcing the impression of a frozen moment that this picture gives.

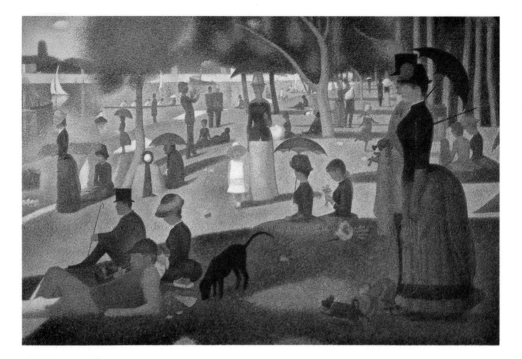

VINCENT VAN GOGH Van Gogh (1853–90), having taught in a school, studied for the ministry and worked as a missionary in Holland and Belgium, turned to painting full-time shortly after 1880. Passionate, sensitive and highly intelligent, van Gogh experienced little success in his lifetime in any undertaking, and his personal life was filled with tragedy and pain. His early paintings, such as *Potato Eaters*, are dark and mostly portray peasant life.

When he moved to Paris in 1886 (a decade before, he had worked there for an art dealer), it was a favourable time for an art student committed to the avant-garde. Numerous exhibitions were showing the work of the new painters, and a number of recently founded periodicals were publishing the work of the new writers as well. Vincent's brother Theo, an art dealer, supported him and introduced him to the Impressionists, who welcomed him. Intrigued by their paintings and ideas, van Gogh soon lightened his palette, turned to Paris scenes, and briefly experimented with the theories of Seurat and his follower Paul Signac. For example, in some of his portraits, he used the device of a halo of colours complementary to the background, as in the *Self-Portrait* of 1887. He was also inspired by the Japanese prints in Bing's gallery, from which he made many copies.

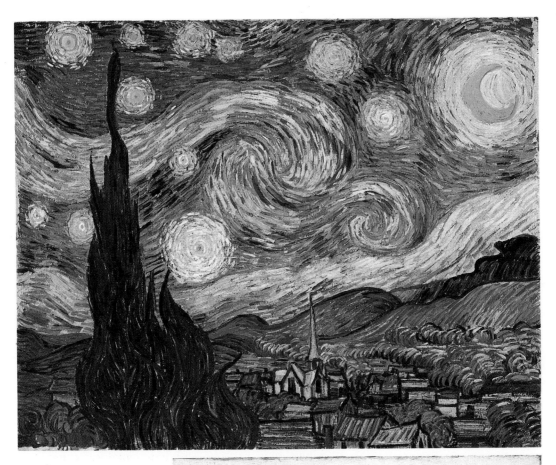

above
Vincent van Gogh, *The Starry Night*, 1889, oil on canvas, 73.7 × 92 cm, collection, The Museum of Modern Art, New York. Acquired through the Lillie P. Bliss Bequest.

right
Vincent van Gogh, *Irises*, 1890, 73 × 93 cm, The Metropolitan Museum of Art, New York, gift of Adele R. Levy, 1958 (58.187).

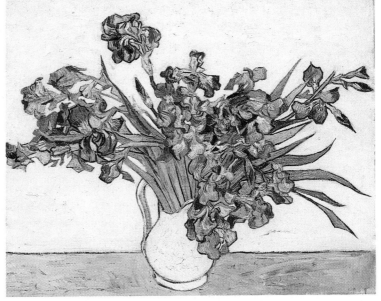

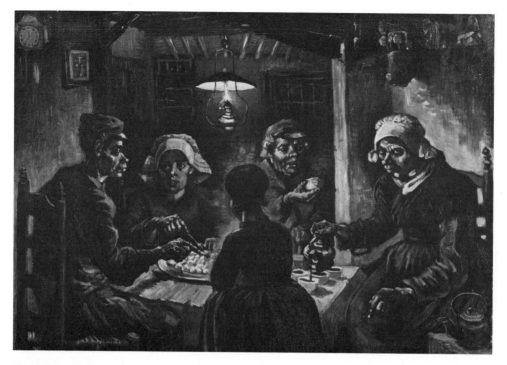

Vincent van Gogh,
Potato Eaters, 1885, oil
on canvas, 82 × 114 cm,
Stedelijk Museum,
Amsterdam.

Gradually, van Gogh's explosive and unpredictable behaviour alienated painters, models, almost everyone but Theo. Even though Theo felt the strain, he believed in his brother's talent and understood Vincent's psychological needs.

In 1888, by which time Paris became less tolerable for him, Vincent went to Arles to work in solitude; he dreamed of setting up a studio there that would attract the Paris painters. Gauguin visited him and carried the message of Synthetism, to which van Gogh responded with his customary enthusiasm. For example, *The Starry Night*, painted the following year, bears a formal connection with Gauguin's new style in the outline of hills, houses and church, while the turbulent forms and eddies of intense colour against the sombre night creates a haunting mood aligned to the Symbolist sensibility. Van Gogh's by now distinctive brush strokes, like so many commas, and the variety of his surface ranging from thick and heavy impasto to intermittent areas of raw canvas that appear to be lightly stained, which created this melancholy picture, could also be turned to pure enchantment, as in some of his flower pictures of the same time. He was particularly attracted to varying contrasts of primaries and complementaries such as red gladioli in a blue vase against a yellow background or orange lilies against a blue background.

After a while, Gauguin's visit proved too unsettling for van Gogh and they quarrelled. When drunk, van Gogh cut off a piece of his ear, which led to an investigation by the local police. Frightened already by van Gogh's erratic behaviour, this event made Gauguin let Theo know of his brother's condition and leave Arles. With him went van Gogh's dream of an artist's studio in the south.

During a series of emotional breakdowns and spells in asylums in Arles, St Rémy, and Auvers, van Gogh painted many landscapes, flower pictures and self-portraits (he painted more self-portraits than any other artist, except Rembrandt) in heightened colour with a vivid expression of light and feeling. The intense joy in the presence of nature that many of these canvasses express betrays nothing of van Gogh's personal torment.

Taking a room in an inn at Auvers to plunge himself into his work, undistracted, van Gogh experienced a brief productive period of calm and optimism. Then, unnerved by problems Theo was having with his gallery which Vincent thought would interfere with his financial support, and by a quarrel with his doctor, he suffered another emotional crisis of profound despair. At dusk, on Sunday 27 July 1890, van Gogh walked out into a nearby field and shot himself. But even in suicide, success seemed to elude him. The bullet missed his heart, but could not be removed. According to one account, he returned to his room, where he lay until discovered by the innkeeper, who came to call him for supper. Theo was summoned, and the following Tuesday Vincent died in his brother's arms. Theo never recovered from the loss; five months later, he died in Holland at the age of thirty-three from what his doctor called 'emotional stress'.

Theo's death was keenly felt by the avant-garde painters. He understood their work and had known how to build a clientele who appreciated the contribution the Post-Impressionists had made to this period of artistic transition at the end of the nineteenth century.

Notes on artists

BURNE-JONES, SIR EDWARD, born Birmingham 1833. Planned church career but changed to art under influence of Morris (a friend at Oxford) and Rossetti. Travelled in Italy 1859, accompanied Ruskin there in 1862 and copied Tintoretto for him. Later works reflect taste for Botticelli. From 1877, his late Victorian Romanticism brought public acclaim and success. Much of his best work is in designs for stained glass and tapestries for the Morris firm. Died 1898.

CANOVA, ANTONIO, born 1757. Trained as a stone mason in Venice. Early portraits reflect French Rococo style, which he rejected by the late 1770s. Settled in Rome in 1781, became the leading Neoclassical sculptor of the period with such works as his monument to Pope Clement XIV in Rome and his tomb for Countess Maria Christina in Vienna. Widely acclaimed antique statuary was a major influence on his figures, for example, *Perseus with the Head of Medusa* based upon the *Apollo Belvedere*, and *George Washington* for North Carolina (now destroyed) Statehouse derived from one of the Elgin Marbles. Died 1822.

CEZANNE, PAUL, born 1839. The son of a rich banker in Aix-en-Provence, Cézanne abandoned study of law for painting. His early paintings, Romantic fantasies based upon his admiration for Rubens and Delacroix, were clumsy and brought ridicule. Through the Académie Suisse in Paris, however, he met the Impressionists, in particular Pissarro, who encouraged him to paint nature. Exhibited with the Impressionists but remained isolated, partly because of his personality, partly because his structural analysis was foreign to Impressionism. First exhibition 1895. Cézanne's mature style was a bridge to modern art, especially Cubism. Died 1906.

CONSTABLE, JOHN, born East Bergholt, Suffolk, 1776, eldest son of a prosperous miller. Became, with Turner, the leading English Romantic land-scape painter of the nineteenth century. Unlike contemporary painters, resisted foreign travel preferring to paint his own countryside almost exclusively. Constable combined idealism of Claude, Dutch seventeenth-century landscape painters, and the old masters with a new naturalism that had immediate influence on Barbizon painters and Delacroix. His *Hay Wain* won a Gold Medal at Paris Salon 1824; his painting theories later influenced the Impressionists. Recognition in England came late; elected R.A. 1829. Died 1837.

COURBET, GUSTAVE, born 1819, Ornans, France. Came to Paris 1840 and joined Académie Suisse. Introduced the new Realism with *The Stonebreakers* (1849), *Burial at Ornans* (1850); painted *The Artist's Studio* in 1855, his quasi-philosophical manifesto. He had won a Gold Medal in 1849, but was later much criticised in the Salon, and answered official neglect by holding private exhibitions in 1855 and 1867, a precedent for the Impressionists. A revolutionary, he was imprisoned and fined for his part in destroying the column commemorating Napoleon in the Place Vendôme, which precipitated his flight to Switzerland where he died. He knew Monet, and inspired the Impressionists in their modern subjects, free brushwork, and opposition to academic art, becoming an example of independence and self-determination to many artists since. Died 1877.

DAVID, JACQUES-LOUIS, born 1748. Formed his style in Rome 1775–81, and there in 1784–5 painted *Oath of the Horatii*, epitome of French Neoclassical painting and significant for its political implications. Identifying himself with the aims of the Revolution, became virtual dictator of the arts and designed propaganda spectacles to promote political aims. An ardent admirer of Napoleon, after Waterloo fled France and retired to Brussels. Influenced contemporary portraiture with numerous official commissions. Died 1825.

DEGAS, HILAIRE GERMAIN EDGAR, born Paris 1834 of a wealthy family. Studied with a pupil of Ingres, whom he admired, but by late 1860s had developed a freer style influenced by his friend Manet and the future Impressionists. In 1872–3, during a visit to New Orleans, he began introducing unusual viewpoints into paintings of contemporary subject matter. From 1874, exhibited with the Impressionists, whom he helped to organise. Degas mastered many media, including pastel, monotype, and in his later years, sculpture. Died 1917.

DELACROIX, EUGENE, born 1798. The leading French Romantic painter, Delacroix admired Géricault, was inspired by Veronese and Rubens, and influenced by the freedom of Constable's work which he saw in Paris 1824 and possibly in England 1825. For his innovation, and his politically sensitive subjects, he was subject to official hostility, led by Ingres. Nonetheless, he received large mural commissions during the 1830s, but was elected to the Institut, founded by David, only in 1857. Died 1863.

FRIEDRICH, CASPAR DAVID, born 1794, studied at Copenhagen Academy then settled in Dresden in 1798. Friedrich declined the normal education in Italy and developed a personal landscape style to express his pessimistic philosophy. Though his early paintings were controversial, and he taught at Dresden Academy from 1816, he had little immediate influence. Died 1840.

GAUGUIN, PAUL, born Paris, 1848. One of the few artists to write an autobiography (*Noa Noa, c.* 1893–4), his life and abandonment of civilisation for the South Seas has had almost as much symbolic significance as his art. He spent part of his childhood in Lima, Peru. Took up painting part-time in 1874, inspired by first Impressionist Exhibition and meeting Pissarro, after a career in merchant marine and as a stockbroker. Two years later, a landscape was accepted by the Salon, and in 1879 began exhibiting with the Impressionists. Became full-time painter 1883, and settled in Pont-Aven, Brittany, where, under the influence of Émile Bernard, he developed Symbolist theories of Synthetism. Following trips to Panama and Martinique and an unsuccessful attempt to work with van Gogh in Arles, rejected Western civilisation and went to Tahiti seeking 'oneness with nature'. Painted *Where Have We*

Come From? What Are We? Where are We Going? 1897. Died in the Marquesas Islands 1903.

GERICAULT, THEODORE, born 1791, studied with academic painter Guérin (also Delacroix's teacher). Rejected prevailing Neoclassicism, studied Rubens, and began painting direct from the model without preparatory drawings. In Italy 1816–18 studied Michelangelo and the Baroque. His *Raft of the Medusa* combined Baroque design, Romantic Realism, and anti-government sentiments. Admired Bonington and Constable and was in England 1820–22 to exhibit his *Raft* and paint horses. Although short, his career was influential, especially his modern subjects, free execution, and depiction of movement. Died 1824.

GOGH, VINCENT VAN, born Netherlands 1853, the son of a Protestant pastor. First, worked for art dealers in London, Paris, and The Hague, then studied for the ministry and became a missionary among miners in Belgium. Took up painting around 1881. Early paintings were naturalistic and carried a social message. Joined his brother Theo in Paris in 1886 where he discovered the Impressionists. Other influences include Rubens, the Japanese print, and Gauguin's Synthetism. In 1888, he settled in Arles, joined briefly by Gauguin. Following a series of emotional breakdowns, van Gogh committed suicide at Auvers 1890.

GOYA, FRANCISCO DE G. Y LUCIENTES, born near Saragossa 1746, studied under the portrait painter Bayeu and visited Rome 1771. Began successful career in 1776 designing cartoons for Royal tapestry works; became Principal Painter to the King 1799. He recorded the atrocities of French occupation of Spain 1808–14 in key paintings, *Second May* and *Third May, 1808* and series of etchings *The Disasters of War*, which exerted formative influence on European painting and print-making in the nineteenth century. The series of etchings *Los Caprichos* (1796–8), satirical attacks on contemporary authority and customs, reflect his powers of fantasy, insight, and invention. The frankness and perspicacity he exercised in portraits of royalty continue to puzzle historians. Died in Bordeaux in voluntary exile 1828.

INGRES, JEAN AUGUSTE DOMINIQUE, born 1780 at Montauban, son of an artist. Studied with David

in Paris where he won Prix de Rome 1801. Studied and worked in Italy from 1806 to 1824 when he returned with *The Vow of Louis XIII* which was acclaimed at the Salon and established him as the official proponent of Classicism in opposition to Delacroix and the Romantic Movement. His enormous power in the Academy and resistance to new ideas stultified official art, but his superlative draughtsmanship and precise vision exerted a positive influence on the styles of contemporaries as well as on future generations of artists. Died 1867.

MANET, EDOUARD. Born Paris 1832, to a well-to-do bourgeois family, he studied with Couture, a history and portrait painter and outstanding teacher, whose free brushwork and strong tonal contrasts prepared Manet for the works of Velazquez, Goya, and Hals, some of his major models. Desirous of official recognition but unwilling to repress his novel ideas of style and composition, his paintings were criticised for their lack of finish and poor draughtsmanship. An influence on the Impressionists, he rejected association with them, but later in his career lightened his palette under their influence. As he was dying, embittered by the long delay in official recognition of his work, he was awarded the Legion of Honour. Died 1883.

MILLAIS, SIR JOHN EVERETT, born 1829. A child prodigy, he entered RA Schools aged eleven and was founder member of Pre-Raphaelite Brotherhood, 1848, aged nineteen. Influenced and championed by Ruskin until 1854 when he stole the affections of and married Ruskin's wife; gradually his style changed to a broader, more socially acceptable post-Raphaelite manner. Died 1896.

MILLET, JEAN FRANÇOIS, born 1814 into a peasant family. Trained under a local painter in Cherbourg, then studied with Delaroche in Paris, 1837. Influenced by Daumier, worked in a pastoral style with socialist overtones which he developed further at the village of Barbizon in the Forest of Fontainebleau, beginning in 1849, with Théodore Rousseau, Narcisse Diaz, and others. Influenced by Corot, Dutch seventeenth-century landscape painters, and Constable, members of this group, called the Barbizon School, were precursors of Impressionism. Died 1875.

MONET, CLAUDE, born in Paris, 1840, grew up in Le Havre, the best known member of the Impressionist group. Persuaded to become a landscape painter by Boudin, who introduced him to *plein air* painting near Le Havre. Went to Paris in 1859 where he studied briefly at the Gleyre studio and met the major painters of the period. Remained faithful to the principle of fidelity to visual sensation, the foundation of Impressionism, long after other members of the group had discarded it. Executed series of paintings of one subject to record the changing effects of light and colour at different times and different seasons: haystacks, poplars, facade of Rouen Cathedral, the Thames. In his late paintings of water lilies, form is almost totally dissolved in pools of colour, which anticipates later Abstract Art. Died 1916.

MORRIS, WILLIAM, born 1834. Designer, architect, painter, a close friend of Burne-Jones and Rossetti with whom he collaborated, Morris opposed the Industrial Revolution as a destructive force, and sought through a revival of the medieval craft tradition the spiritual regeneration of man. To further his ideas, founded Morris and Company in 1861 producing interior furnishings along the lines of the medieval workshop. His influence was widespread in both the field of late nineteenth-century design and the development of the Socialist Movement. Died 1896.

RENOIR, PIERRE AUGUSTE, born 1841, son of a poor tailor from Limoges. At age thirteen, worked as a painter in a Paris porcelain factory; 1861, studied painting with Gleyre where he met Monet, Bazille, and Sisley. Formed his early style on Courbet, but his study of Watteau, Boucher, and Fragonard, recalling the porcelain designs at the factory, brought the light tonality of French eighteenth-century painting to his palette. Exhibited in four Impressionist exhibitions, but his dedication to the figure, financial need to sell his work, and interest in the antique and the old masters after visiting Italy drew him away from the Impressionist mainstream. Always alert to new developments, took particular interest in Matisse and the Fauves in his late years. Died 1919.

RODIN, AUGUSTE, born 1840 Paris. Worked first as a stone mason, and in 1871 executed decorative figures on Brussels Stock Exchange. Admired Michelangelo and Puget; studied with Barye and

Carrier-Belleuse in Paris; failed entrance to the École des Beaux-Arts. First important work, *The Age of Bronze* (1875–6) criticised as merely a cast of the model. In *St John the Baptist Preaching* (1878–80), Rodin introduced a theme that became central to his art, the figure realising itself through action. 1880 began most famous work, *The Gates of Hell*, which occupied him the rest of his life and was never finished. From it came many of his subjects, such as *The Thinker*, which he also selected as his tombstone. Most influential sculptor of the period; lived to see his works universally accepted. Died 1917.

ROSSETTI, DANTE GABRIEL, born London 1828, son of an Italian political refugee. Studied with John Cotman and Ford Madox Brown, then under Holman Hunt with whom he formed the Pre-Raphaelite Brotherhood along with John Everett Millais in 1848. Rossetti's first major picture, *The Girlhood of Mary Virgin* (1849), was also the first to be exhibited with the initials 'PRB'. The idea of a secret brotherhood and its rejection of Raphael provoked many academicians which led to John Ruskin's defence of the group and assured their early success. Rossetti gradually withdrew from the naturalistic style of the early Pre-Raphaelite paintings into a medievalising dream-world that revolved around his model, Elizabeth Siddal, whom he married in 1860, and who died of narcotics in 1862. Rossetti died a recluse and himself an addict in 1882.

ROUSSEAU, THEODORE, born 1812. Landscape painter, began painting direct from nature *en plain air c.* 1830; early works rejected by Salon. By 1846 settled in Barbizon near Forest of Fontainebleau and with Millet, Diaz, and others formed a community of landscape painters called the Barbizon School. Influenced by Dutch and English landscape painters, developed a naturalistic style that later influenced the Impressionists. Died 1867.

SEURAT, GEORGES, born 1859. Influenced largely by Delacroix, Ingres, Puvis de Chavannes, and the Impressionists, united classical composition with contemporary colour theories of Chevreul and others. Replaced traditional brushstroke with system of uniform dots called Divisionism (popularly dubbed Pointillism). Developed theory called Neo-Impressionism, incorporating the new brushstroke, described by his follower, Paul Signac,

in *From Delacroix to Neo-Impressionism* (1899). Explored the correlation of colour and emotion. Died 1891.

SISLEY, ALFRED, born Paris 1839, of English parents. At Gleyre's studio, met Monet, Renoir, and Bazille. Soon after, devoted himself almost entirely to landscape and became a leading Impressionist. Influenced by contemporary landscape painters, especially the theories and technique of Turner. Died 1899.

TURNER, JOSEPH MALLORD WILLIAM, born London 1775, son of a barber. Began career as a topographical landscape painter in the picturesque tradition influenced especially by the watercolours of John Robert Cozens and Thomas Girtin. Developed rapidly and elected RA in 1802, when he made one of many continental sketching tours – trips through the Alps, to Paris, and Venice which made lasting impact on his composition and colour. A major influence throughout his career was Claude whom he tried to surpass. Developed a painterly style charged with dramatic power inspired by the forces of nature and an abiding pessimism. A leading colourist, Turner had a profound influence on the Impressionists later. Died 1851.

WHISTLER, JAMES ABBOTT McNEILL, born Lowell, Mass., 1834. Failing to graduate from West Point Military Academy, worked as a cartographer for the US Government in Washington DC, where he learned etching. Travelled to London and then to Paris in 1855, where he studied briefly at Gleyre's studio. Worked with Courbet whose spontaneous and free style attracted him, at first. Later, regretted that he had not followed the more exacting guidelines of Ingres whose accurate drawing and command of colour and composition he grew to admire. Settled in London in 1859, and developed a style based upon precise but subtle relationships of tone and shapes, analogous to tonal intervals in music, the reason he called them 'arrangements', 'notes' and 'nocturnes'. Won suit against Ruskin in 1878 for libel but court costs bankrupted him. Series of etchings he made in Venice trying to recover financially following the trial are among his most outstanding works. Died 1903.

Glossary

AQUATINT a type of etching in which rosin powder is melted on the plate to create a sandpaper-like texture for printing large tonal areas.

CHIAROSCURO a combination of two Italian words, literally 'light-dark', but in art means how light and shadow are balanced and handled by the artist in a painting.

CONTRAPPOSTO an Italian word, meaning counterpoise or set against, used to describe the human body's pose in which the vertical axis of the standing figure becomes an attenuated S-curve. One leg (the 'engaged' leg) supports the main weight of the figure as shoulders and hips slant in opposite directions to maintain equilibrium. Developed by the Greeks in antiquity, contrapposto expresses movement and life.

ECLECTICISM the selection of elements from different sources to create a new style.

HISTORY PAINTING the noblest expression of the Grand Style, it featured heroic subjects from history, mythology, and the Scriptures.

ICONOGRAPHY the study of the symbolic meaning in works of art and the imagery that conveys that meaning.

IMPASTO refers to thickly applied pigment in a painting, characterised by uneven surfaces and the appearance of deep brushstrokes.

LITHOGRAPHY a printmaking process invented by Alois Senefelder *c*. 1798 in which an image is printed from a flat stone or plate rather than from a raised or incised surface. Therefore, it differs from the woodcut, a relief whose raised surfaces print the image, and from engravings and etchings, whose incised recesses print the image.

LOCAL COLOUR the actual colour of an object in a painting uninfluenced by reflected light.

PAINTERLY translated from *malerisch*, a German word used by Swiss art historian, Heinrich Wölfflin, to describe a style of painting in which objects are portrayed as patches of colour or light and shade. Their soft and unclear outlines appear to merge with each other and for that reason denote the opposite of a linear style in which objects are enclosed by sharp, clear, and distinct lines.

PALETTE the board or pad, usually with thumb-hole and finger grip that dictate its distinctive shape, on which a painter arranges his colours. The term also refers to the range of colours an artist uses in a specific painting as well as the range of colours that characterise the artist's body of work.

VEDUTA the Italian word for view, used to describe a painting or drawing of a place.

Further reading

THE HISTORY OF ART

Eichenberg, Fritz. *The Art of the Print*. Abrams, 1976

Gardner, Helen. *Art Through the Ages*, 6th edn. Harcourt Brace Jovanovich, 1975

Gombrich, E. H. *The Story of Art*. Phaidon, 1978

Janson, H. W. *History of Art*. Prentice-Hall and Abrams, 1974

NINETEENTH CENTURY ART

Novotny, Fritz. *Painting and Sculpture in Europe 1780–1880*, 2nd edn. Penguin, 1970

Licht, Fred. *Sculpture: Nineteenth and Twentieth Centuries*. New York Graphic Society, 1967

Hamilton, George Heard. *Nineteenth and Twentieth Century Art*. Abrams, 1970

Hitchcock, H. R. *Architecture: Nineteenth and Twentieth Centuries*. Penguin, 1967

MOVEMENTS AND STYLES

Anscombe, Isabelle and Charlotte Gere. *Arts and Crafts in Britain and America*. Rizzoli, 1978

Clark, Kenneth. *The Romantic Rebellion*. Harper & Row, 1973

Hilton, Timothy. *The Pre-Raphaelites*. Abrams, 1970

Honour, Hugh. *Neo-Classicism*. Penguin, 1968

Honour, Hugh. *Romanticism*. Harper & Row, 1979

Jullian, Philippe. *Dreamers of Decadence*. Praeger, 1971

Meeks, Carroll L. V. *The Railroad Station, an Architectural History*. Yale University Press, 1956

Praz, Mario. *The Romantic Agony*. Meridian Books, 1965

Nochlin, Linda. *Realism*. Penguin, 1971

Rewald, John. *The History of Impressionism*. Museum of Modern Art, 1973

Rewald, John. *Post-Impressionism, from Van Gogh to Gauguin*. Museum of Modern Art, 1978

Schmutzler, Robert. *Art Nouveau*. Abrams, 1977

Spencer, Robin. *The Aesthetic Movement*. Dutton, 1972

Staley, Allen. *The Pre-Raphaelite Landscape*. Clarendon Press, 1973

Index

Index

Index